Dear Mozell,

Someday I'd be looking
thru a book of your painting!
You have and are one of lifes
blessings. Thanks for sharing my
life. This not good bye, just
see you later in round I.

Love always
Dianne.

MARY CASSATT

AN AMERICAN IMPRESSIONIST

GERHARD GRUITROOY

SMITHMARK

This edition published in 1996 by SMITHMARK Publishers,
a division of U.S. Media Holdings, Inc.,
16 East 32nd Street, New York, NY 10016.

SMITHMARK books are available for bulk purchase
for sales promotion and premium use.

For details write or call the manager of special sales,
SMITHMARK Publishers,
16 East 32nd Street, New York, NY 10016;
(212) 532-6600.

This book was designed and produced by
Todtri Productions Limited
P.O. Box 572, New York, NY 10116-0572
FAX: (212) 279-1241

Printed and bound in Singapore

Library of Congress Catalog Card Number 96-68015
ISBN 0-7651-9960-2

Author: Gerhard Gruitrooy

Publisher: Robert Tod
Book Designer: Mark Weinberg
Production Coordinator: Heather Weigel
Senior Editor: Edward Douglas
Project Editor: Cynthia Sternau
Assistant Editor: Linda Greer
Desktop Associate: Michael Walther
Typesetting: Command-O, NYC

PICTURE CREDITS

CONTENTS

INTRODUCTION

The fate of most individuals who gain fame and fortune abroad is to be less successful in their own countries. This generalization does not apply—at least today—to the American-born painter Mary Cassatt, who spent the better part of her life and career in France. Her identification with the cause of French Impressionism during the heyday of the movement in the last quarter of the nineteenth century did not prevent her from gaining a heroic position among artists in her native country. Indeed, the majority of her works are found today in American collections, while just a small number of paintings remain in France, where her name is much less familiar than those of her fellow Impressionist painters Degas, Monet, or Renoir. However, Cassatt's fame in the United States was won slowly, after a period of continued struggle, and began to manifest itself only after the turn of the century when the main body of her work had already been created.

From her childhood onward Cassatt was a free-spirited, independent-minded, and determined person who relentlessly pursued her goal of becoming not only an artist, but a great artist. This strong will never left her throughout her entire life. As the French traveler Alexis de Tocqueville commented in his famous work *Democracy in America* (published 1835–1840), an American girl "has scarcely ceased to be a child when she already thinks for herself, speaks with freedom, and acts on her own impulse." These same characteristics apply fully to Cassatt, who, with a mind of her own, acted at times against the wishes of her family, particularly concerning her father's reservations about her choice of career. After all, the Cassatt family belonged to the upper middle class of Pennsylvania, and she was expected to conform to the standards of her social background.

However, unlike the common assumption that women of the Victorian era were individuals struggling for freedom and independence from social constraints, Mary Cassatt was not alone. She had many female peers among her fellow

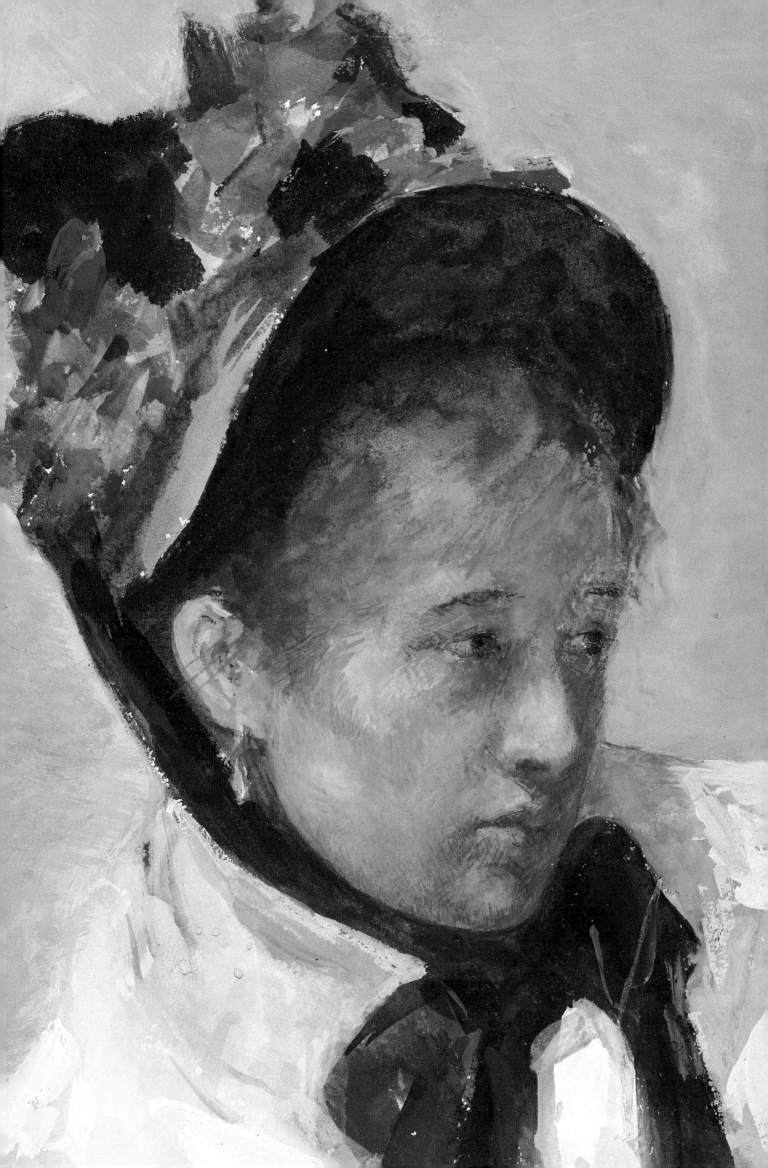

artists, women such as Berthe Morisot or Eva Gonzàles, and she also befriended many successful women who would later become active in the suffrage movement, foremost among them Louisine Havemeyer. Emily Sartain and Elizabeth Gardner, both of whom were equally determined to become artists, were Cassatt's companions during her years of training at the Pennsylvania Academy of Fine Arts. All three women later went to study in Paris, and the letters they wrote to their families are full of details about career plans and their high expectations for professional success.

The theme of the contemplative woman who reflects on her own role was to become a central point of reference throughout Cassatt's career. Her own mother played a crucial role in her daughter's successful artistic development by bringing her to Europe as a young art student (against her father's wishes) and it was in Paris that she would spend most of her life. Other women on both sides of the Atlantic were to become active supporters of Cassatt's art. When, toward the end of her life, her family in the United States joined the anti-suffrage camp, Cassatt considered this move to be not only a lack of appreciation for her own work, but also a renewal of her conviction that she could not have accomplished all she had done if she had returned to Philadelphia after only a few years of study. Even when her family urged her to come home after the outbreak of World War I, Cassatt felt that her place was in Europe. "After all give me France," she wrote to a friend. "Women do not have to fight for recognition here, if they do serious work."

Indeed, at the time of her death in 1926 Cassatt was considered to be the leading woman artist in the United States, although she had not painted for more than twelve years due to failing eyesight.

Head of a Young Girl
c. 1876, oil on panel; 12 3/4 x 9 in.(32.3 x 22.9 cm).
Gift of Walter Gay, Museum of Fine Arts, Boston.
Cassatt's increasing dissatisfaction with the requirements of the conservative judges of the annual Salon can be well measured when studying this small oil sketch. By building up the painting's rich surface with a colorful network of quick brushstrokes, Cassatt followed the lesson of Thomas Couture's teaching and rejected the slick style of academic artists like Jean-Léon Gérôme. Her vibrant, exuberant palette emphasizes the reflections of the light on the sitter's blouse, as perceived by the eye.

Young Woman Sewing in a Garden
detail; c. 1883–1886. Musée d'Orsay, Paris.
Sewing and other types of needlework were important and customary activities among the women in the Cassatt family, who made much of their own clothing, as was usual at that time.

THE EARLY YEARS

*M*ary Stevenson Cassatt was born on May 22, 1844, in Allegheny City, Pennsylvania (across the river from Pittsburgh), the fourth surviving child and second daughter to a well-to-do family. Her father, Robert Cassatt, was a successful stockbroker and financier; he made his political contribution by becoming a council member twice and then mayor of Allegheny City. Mary's mother, Katherine Kelso Johnston, her husband's junior by ten years, came from a banking family which had provided her with the best possible upbringing, including a French-speaking governess who gave her a Continental education. The Cassatt family was of French Huguenot origin; their ancestors had disembarked in New York in 1662 after escaping religious persecution in France. The family name was originally spelled Cossart; it evolved to Cassat at the beginning of the nineteenth century, and eventually assumed its current form around the time of Mary Cassatt's birth.

Childhood and Early Education

The restless spirit of a rapidly developing country combined with Mr. Cassatt's acute sense of entrepreneurship led his family onto a path of constant motion, first bringing them back to Pittsburgh, then to a country home in Lancaster, Pennsylvania, and finally to Philadelphia. However, Robert Cassatt seems to have

Two Women Seated by a Woodland Stream
c. 1869, oil on canvas; 9 1/2 x 13 in. (24 x 33 cm).
Musée de la Ville de Paris, Musée Carnavalet, Paris.
This study of two women seated under trees on the bank of a brook is one of the few works by Cassatt where the dominant feature is the landscape rather than the figures. Although painting *en plein air* was a hallmark of the Impressionist movement, Cassatt usually treated the landscape as a secondary aspect in her work, relegating it to the background. The sketchy character of this work seems to indicate that it was never finished.

A Musical Party

1874, oil on canvas; 38 x 26 in. (96.4 x 66 cm).

Musée de la Ville de Paris, Musée Carnavalet, Paris.

Done during a visit to Rome, this painting shows some of the characteristics of Gustave Courbet's works: thickly applied paint with white highlights against a dark background. The heads of the three figures are arranged in an S-shaped curve. Cassatt's friend, Emily Sartain, commented on this work (in a letter to her father) as being "superb and delicate in color . . . The light on the chest and face of the foreground figure, a blonde, is perfectly dazzling. It is as slovenly in manner and in drawing as her Spanish pochades [sketches], however."

preferred a comfortable life of leisure to the mere acquisition of wealth. He decided only two years after their arrival in Philadelphia to take his entire family on a prolonged tour to Europe, possibly lured by the Great Exhibition at London's Crystal Palace held during the summer of 1851. From there the Cassatt family continued their trip to France, where they spent almost two years in Paris. This predilection for French culture was probably due to Mrs. Cassatt's education. She spoke French fluently, and the children were sent to local schools to master the language and absorb the French culture.

When Mary's older brother Alexander developed an interest in a technical career, the family moved again in 1853, this time to Heidelberg, Germany, and later to Darmstadt, where the boy attended the renowned Technische Hochschule. It was there that their second son, Robert, died of a bone disease in May of 1855. Soon the Cassatts decided to go back to America, stopping briefly in Paris to see the Exposition Universelle (World's Fair) of 1855. Although Mary was only eleven years old at that time, she might have seen the art section of this World's Fair with its large exhibitions of works by Ingres and Delacroix, and also Courbet's unofficial "*Pavillon du Réalisme.*" Whether Mary benefited from such an experience remains mere speculation, but it could well have stimulated her desire to become an artist.

The Pennsylvania Academy

During her four-year stay in Europe Mary had not only become fluent in French and German, but she had also been exposed to the diversity and richness of a variety of European cultures. Returning to Pennsylvania in 1855, the Cassatt family settled first in West Chester outside of Philadelphia, then moved again into the city in 1858, possibly to offer their children the advantages of higher education and to allow for introductions into society.

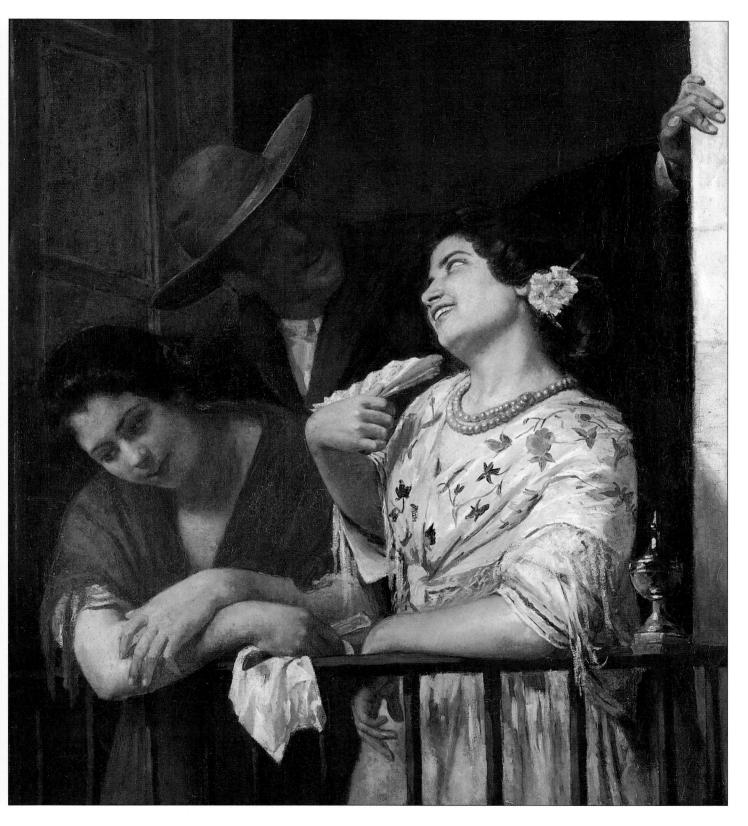

On the Balcony, During Carnival

1873, oil on canvas; 39 3/4 x 32 1/2 in. (101 x 82.5 cm). The W. P. Wilstach Collection, Philadelphia Museum of Art, Philadelphia.
Two women and a man in Spanish costumes are shown on a balcony observing an unseen carnival below. This was
the first of several paintings depicting Spanish characters and is indebted to Edouard Manet's famous painting *The Balcony*,
which in turn was inspired by a work by Goya. Cassatt was also deeply impressed by the Spanish realist tradition
of Velázquez and Murillo, and through these influences her palette became more somber and the paint surface
thicker. As in most of her later works, she already preferred the depiction of people to that of landscapes or still lifes.

La Jeune Mariée ('The Young Bride')

c. 1875, oil on canvas, 34 1/2 x 27 1/2 in. (87.6 x 70 cm). Gift of the Max Kade Foundation, Montclair Art Museum, Montclair, New York.

The model for this work was Cassatt's maid, Martha Gansloser, to whom the painting was presented as a wedding gift. The young woman at her needlework is depicted in a graceful pose and reflective mood.

At the age of fifteen, Mary decided to become an artist and enrolled, in April of 1861, for the next winter class at the Pennsylvania Academy of the Fine Arts in Philadelphia, by which time she would meet the minimum age of sixteen required by the school. Considered the most prestigious academy in the United States, the institution offered a traditional training for its students; first drawing from plaster casts of antique sculpture, then drawing from live models, and finally copying in oil the mostly second-rate paintings housed in the academy's collection.

Female art students in those days were still not fully accepted among their male peers and often had to defend themselves against ridiculing remarks during class. Mary Cassatt soon learned that women artists faced continued skepticism in the pursuit of their goals. Her parents were also not overly enthusiastic about her choosing to take on a career, and they expected their daughter to get married to a man of their class and to have children.

While taking art classes for four years, Mary Cassatt continued to pursue studies on her own, painting from local models in West Chester where her parents had again moved in 1862, and copying at the academy in Philadelphia. As the Civil War drew to a close in 1865, she became increasingly frustrated and dissatisfied with her training. She felt that originality and creative freedom were suppressed, and decided to follow the example of many talented and ambitious art students and go abroad for further studies. The lack of public art collections of any standing in the United States only supported her belief that she needed to improve her knowledge of art matters in Europe, with its famous collections.

There was no doubt that Paris was the obvious choice. Such a decision must have been considered an adventure for anyone, but it was almost unthinkable for a young woman from Mary Cassatt's social background. In fact, her father told her in a burst of anger that he would rather see his daughter dead than have her go off to Europe by herself to become an artist. While it was acceptable and even considered a sign of good breeding for a woman to become an amateur artist or musician, pursuing such a profession seriously in a competitive world must have amounted to outrageous behavior in the context of the traditional life of her family. However, Mary's independent nature and her longing for change was strong, all the more since her friend Eliza Haldeman was also planning a trip to Europe as was another fellow student from the Academy, Thomas Eakins, who was going to be enrolled in the École des Beaux-Arts in Paris.

Paris

At last it was decided that Mary was to leave for Europe accompanied by her mother. This also meant that her chances to get married were put off—at least for some time. Certain self-criticism notwithstanding, Mary, not yet twenty-two years old, was certainly attractive and wealthy enough to lure suitors, but as it turned out, she remained unmarried for the rest of her life, as did her older sister Lydia and three female cousins.

Once settled in Paris, Cassatt's main goal was to find a teacher and to start working. Since the École des Beaux-Arts did not admit women, she petitioned recognized painters who were known to give private lessons. She succeeded in being accepted by Jean-Léon Gérôme, a young painter with a penchant for realist precision in exotic and historic subjects. He was considered by some to be the most gifted draftsman of his time and his name was well known even among academicians back in Philadelphia. In addition, Cassatt registered among the

copyists at the Louvre where many art students, both French and foreign, as well as painters of reputation, could be seen copying works of the Old Masters. Such copies were eagerly sought after, especially by American tourists, who, together with thousands of visitors from all over the world, flocked daily to the museum. For the students the Louvre was also a convenient meeting place where ideas and opinions could be exchanged and friendships made.

The other important public space of the Parisian art world was the annual exhibition at the Salon, to which virtually every artist, young and old, submitted his or her work. A jury with close links to the Academy presided over the selection process, often judging the quality of the works with a conservative and conventional set of rules which favored the dry and academic art taught at the École des Beaux-Arts. Occasionally, however, the jury's decisions were more liberal.

In April of 1868, Cassatt, who had spent more than a year in villages around Paris studying with various painters or working on her own, received the news that her painting of a young woman with a mandolin had been accepted for the Salon. Her deep satisfaction with this first public success was overshadowed by a somewhat cynical feeling about the institution of the Salon itself. A growing discontent had surfaced with the officialdom of a narrowly-defined style controlled by a small group of established artists in Parisian art circles. Eliza Haldeman, Cassatt's closest friend in those days, noted that artists were "leaving the Academy style and each one seeking a new way, consequently just now everything is Chaos. But I suppose in the end they will be better for the change."

Cassatt's ambivalence towards the Salon was to last for almost ten years until 1878, when after repeated rebukes she finally stopped submitting her work altogether. In 1876, just to mock the jury's corruptibility and lack of artistic understanding, she resubmitted a painting which had been rejected the previous year for being too lightly colored. After she toned down the painting's background it was deemed acceptable by the jury, but by then Cassatt's feelings had been seriously hurt.

Manet and Courbet

Other artists ventured out on their own, like Edouard Manet and Gustave Courbet. In 1867 both of these painters, who were sufficiently wealthy and independent, held exhibitions in their private pavilions outside the grounds of the Paris world's fair. Naturally these exhibitions became the art talk of the town. But even less radical artists like Thomas Couture, who withdrew to the countryside under a well-publicized campaign, were no longer willing to subject their works to a process of scrutiny that bordered on parody.

Toreador

1873, oil on canvas; 32 1/4 x 25 1/4 in. (81.9 x 64.1 cm). Bequest of Mrs. Sterling Morton, The Art Institute of Chicago, Chicago.
Single male figures, rare in Cassatt's oeuvre, did not appear until she painted a series of Spanish subjects during her stay in Seville. As in other works from this period, Cassatt was keenly interested in depicting the richly embroidered local costumes. *Toreador* clearly reflects the influence of Manet's Spanish works in its concentration on the effects of light as well as the monochromatic background.

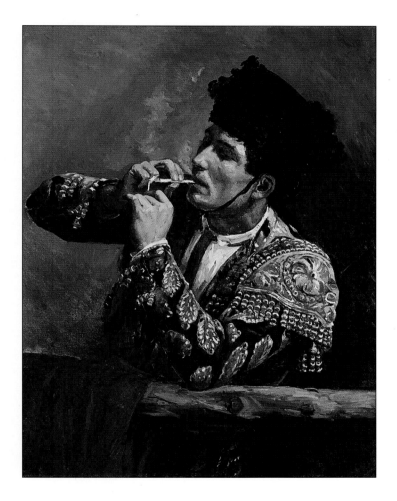

The most important influence on Cassatt in the years before 1875 was exercised by Edouard Manet with his realistic renderings of everyday life. Although he did not accept students, Cassatt could have seen his works not only at the 1867 fair, but also at the Salon, where he continued to exhibit in spite of the maligning comments of the critics. Two works that departed radically from the prevailing taste had earned him a notorious reputation. His *Déjeuner sur l'herbe*, shown at the Salon in 1863, and *Olympia* (1865), had caused a furor which would last well into the next decade. Cassatt might also have noticed the early work of Edgar Degas, who exhibited in the Salons between 1866 and 1870 and whose close friend and

admirer she was soon to become.

These years of study and exploration came to an abrupt end with the outbreak of the Franco–Prussian War in July of 1870, and Cassatt decided to return to her family in the United States. The next year and a half was among the least productive and most difficult times of her entire artistic career. Lacking the inspiring atmosphere of Paris, the availability of certain painting materials, and, above all, access to great collections of art, Cassatt became so discouraged that she was almost ready to give up painting. In the end, however, her strong desire for recognition and independence, and immense will to become a reputable artist capable of earning her own living won, over her doubts. Late in 1871 she was on her way back to Europe, settling in Parma where she was to copy works by Correggio for the archbishop of Pittsburgh. It was with the money earned from this commission that she paid for her travel expenses, since her family was unable—or, more likely, unwilling—to cover the cost of her professional training. Her family's continuing disapproval and misgivings were only slowly replaced by an accepting, even admiring attitude a number of years later.

Parma, Spain, and Beyond

The eight months in Parma were a time of tremendous excitement and success never experienced before—or even later on—in Cassatt's life. Together with her friend and traveling companion, Emily Sartain, also from Philadelphia, she received a warm welcome in the art community of Parma, off the beaten track of famous destinations such as Florence, Rome, or Venice with their large contingents of foreign artists. In Parma the abundance of works by Correggio, a leading painter of the high Renaissance, whose soft, natural style made his indelible mark on Cassatt, and

Young Woman Reading

1876, oil on canvas; 13 3/4 x 10 1/2 in. (34.9 x 26. 6 cm).
Bequest of John T. Spaulding, Museum of Fine Arts, Boston.
This scene of a young woman reading is imbued with the romantic overtones of the decorative style of Cassatt's teacher Charles Chaplin, whose classes for women she frequented from 1867 to 1868, together with her friend Eliza Haldeman. The striped upholstering of the couch serves as a foil before which the figure is placed in a slightly twisted, almost artificial arrangement. This is not yet the determined, independent-minded woman whom Cassatt was to represent in her later work.

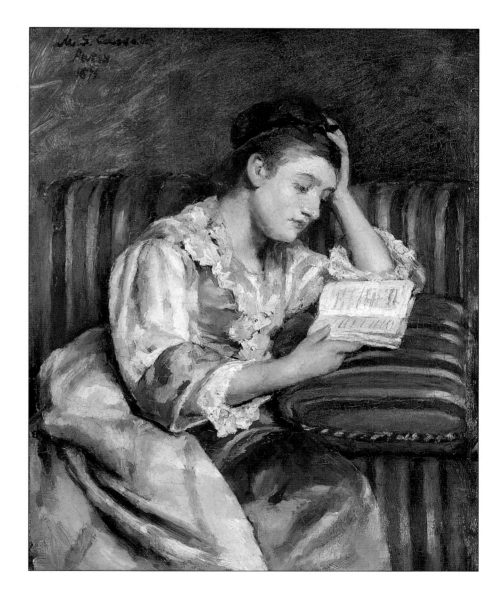

Miss Mary Ellison

c. 1878, oil on canvas; 33 1/2 x 25 3/4 in. (85.1 x 65.4 cm). Chester Dale Collection, National Gallery of Art, Washington, D.C.
The sitter is believed to be Mary Ellison (later Waldbaum, c. 1856–1936), a fellow Philadelphian who was part of a circle of young American expatriates in Paris in the 1870s. The portrait belongs to a series of theater scenes Cassatt painted during that time. As in *The Loge*, she used the pose of an isolated woman holding an open fan to create a contemplative mood and to separate the viewer from the model. A mirror reflecting the sitter's head serves to lighten the traditionally dark background and to enhance the sense of depth.

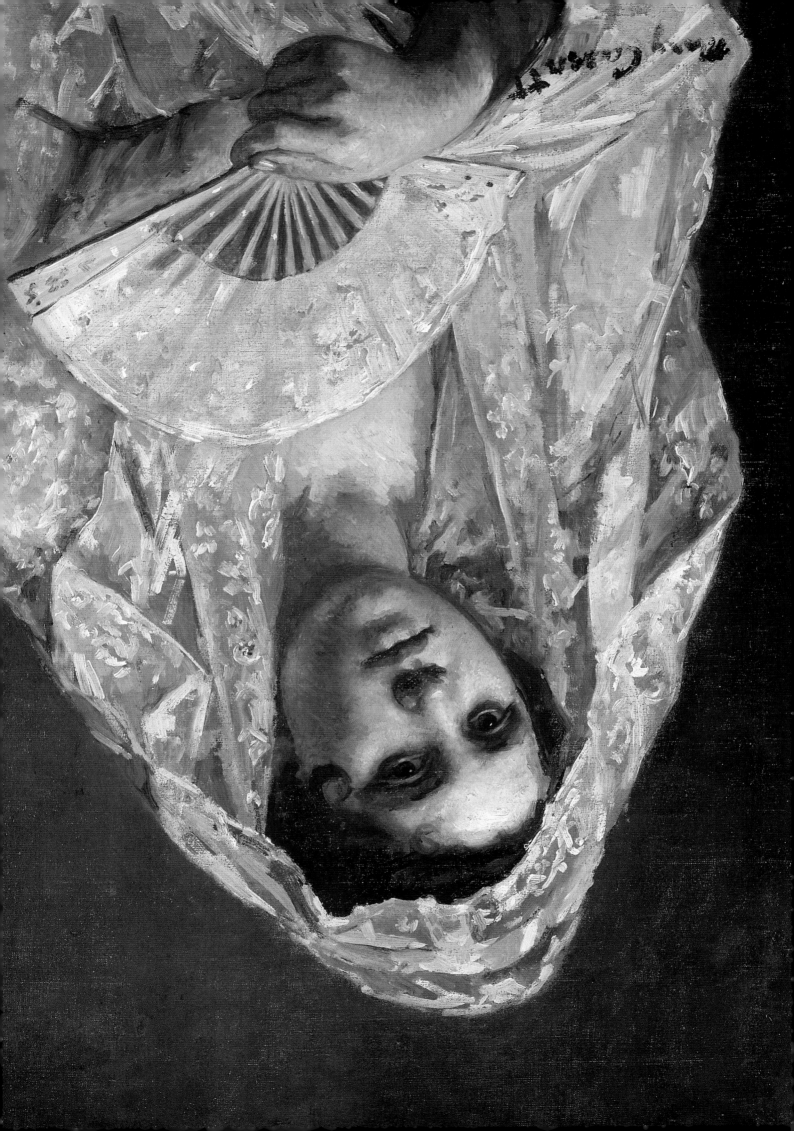

of works by the Mannerist painter Parmigianino, made her prolonged stay in that city a fruitful one. In particular, Correggio's Madonna and child scenes became a source for Cassatt's own mother and child paintings, which today are her best-known and most popular works.

Through Emily Sartain, daughter of the eminent American engraver John Sartain, Cassatt became acquainted with Carlo Raimondi, a professor of engraving at the local academy at Parma. From him she received an introduction to printmaking techniques which she would explore later with great success. When a painting which she had sent from Parma to the Salon in Paris was accepted, Cassatt felt that her career had begun.

In late September of 1872 she went to Spain, studying first the paintings of Velázquez, Murillo, Titian, and Rubens at the Prado, then continuing on to Seville where she began to paint her first major body of works based on Spanish subjects. Fascinated by the bright colors of that city and the local customs of its people, Cassatt painted various models in traditional costumes, as in *Spanish Dancer Wearing a Lace Mantilla*. Manet had painted similar subjects about ten years before, following a widespread fashion for the "exotic" neighbor to the south. After a brief return to Paris in April of 1873, she visited Holland and Belgium, and then traveled back south to Rome. In 1874, after eight years of a restless, nomadic life, Cassatt finally decided to settle permanently in Paris and to face the despised art establishment rather than avoiding it. Aided by her older sister Lydia, who joined her from the United States, she took an apartment and studio. It was the beginning of an intense friendship between the two women which lasted until Lydia's untimely death in 1882.

The Return to Paris

In Paris sales of Cassatt's works were still slow, however, and the recognition she had received in Parma and Seville did not immediately follow her. Nevertheless she was determined to make her way. In the course of time Mary became known as a portrait painter and was sought after by American visitors to France. Mary Ellison, for example, the daughter of a Philadelphia businessman, made Cassatt's acquaintance through mutual friends and asked her father to commission Cassatt to paint her portrait (*Mary Ellison Embroidering*). Cassatt, who valued plain portrait painting less than subjects of her own invention, preferred to position her sitters in genre-type poses, engaged in reading, sewing, or other activities.

In April of 1874, the first exhibition of the Société Anonyme des Artistes Peintres, Sculpteurs, Graveurs, Etc., with works of Edgar Degas, Claude Monet,

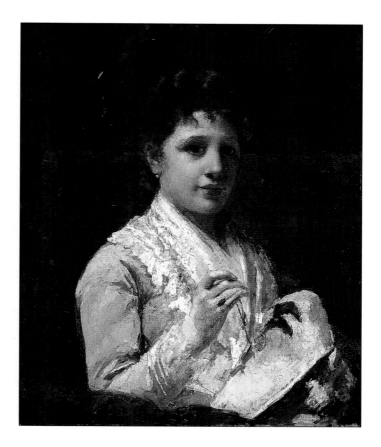

Spanish Dancer Wearing a Lace Mantilla

1873, oil on canvas; 26 3/4 x 19 3/4 in. (65.2 x 50.1 cm).
Gift of Victoria Dreyfus, The Smithsonian Institution,
National Museum of American Art, Washington, D.C.

Prior to 1875 it was Edouard Manet whose work exercised the strongest influence on Cassatt, particularly his paintings of Spanish subjects, such as guitar players, dancers, and toreadors. In the fall of 1872 Cassatt left Italy for Spain. There, after studying the works of Spanish and Flemish masters at the Prado in Madrid, she moved on to Seville, where she produced several paintings of Spanish genre scenes during her six-month stay. This work is a proof of her fascination with the local people and the exuberance of Spanish costumes.

Mary Ellison Embroidering

1877, oil on canvas; 29 1/4 x 23 1/2 in. (74.2 x 59.7 cm).
Gift of the children of Jean Thompson Thayer,
Philadelphia Museum of Art, Philadelphia.

Although not known for being a portrait painter, Cassatt did not hesitate to accept commissions when the occasion arose. In this case she was asked to paint a portrait by Mary Ellison, the daughter of a Philadelphia businessman, who was introduced to the artist through mutual friends in Paris. Cassatt preferred to show her subjects in genre-like poses such as sewing or reading, activities which gave her sitters an air of abstraction and a more generic, typified touch.

Auguste Renoir, Paul Cézanne, Camille Pissarro, and others, took place in the studio of the photographer Nadar on the Boulevard des Capucines. It offered uncensored access to its participants, and had no jury—the only condition was not to submit any work to the official Salon. This was what later became known as the first Impressionist group show. A French critic, who in his review of the show condemned the new style, labeled the artists mockingly as "Impressionists," referring iron-

Breakfast in Bed

detail; 1897, oil on canvas. Virginia Steel Scott Collection, The Henry E. Huntington Library and Art Gallery, San Marino, California. The cup and saucer of this simple breakfast still life have been painted with the same care and attention to detail as the rest of the work. The light is reflected by the surface of the porcelain cup, which has been modeled with broad, thick layers of paint. Cassatt's mature works reveal her assured brushwork and loose handling of colors.

ically to the title of Monet's painting *Impression-Sunrise* (Musée Marmottan, Paris) which was included in the exhibition. Although still intent on gaining acceptance from a system she despised and ridiculed, Cassatt would soon join the ranks of this group of renegade artists.

Among the Impressionists

In 1877, after her final rejection at the Salon, Cassatt was invited by Edgar Degas to exhibit along with him and his fellow painters. He had already noticed her entry for the Salon in 1874, about which he had reportedly said, "Here is someone who feels as I do." Cassatt herself had also admired Degas' work long before she actually met him. Later she reminisced that she had seen his pastels in a dealer's window on the Boulevard Haussmann (probably in 1875): "I used to go and flatten my nose against that window and absorb all I could of his art. It changed my life. I saw art then as I wanted to see it." The first meeting between the two artists, which had been arranged by a mutual friend, the painter

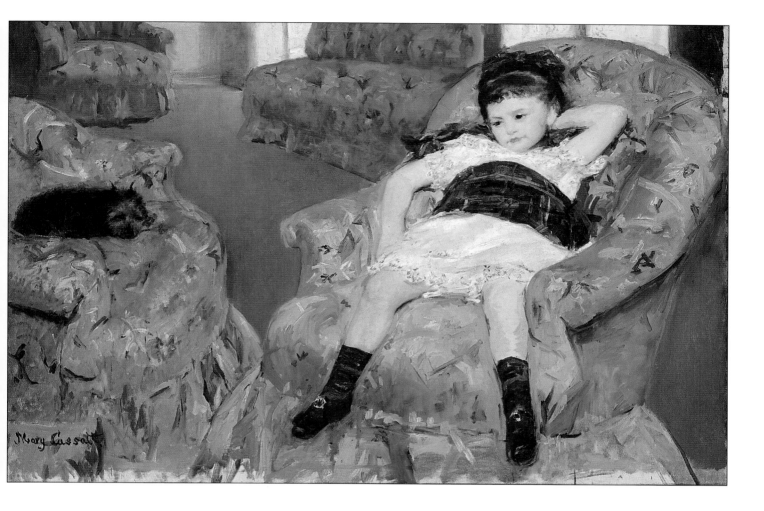

Little Girl in a Blue Armchair

1878, oil on canvas; 35 1/4 x 51 1/8 in. (89 x 130 cm). Collection of Mr. and Mrs. Paul Mellon, National Gallery of Art. Washington, D.C.
Sitting in a languid and somewhat provocative pose, the little girl is relaxing amid an array of four blue chairs. The amusing dog asleep in the chair at the left was one of Cassatt's own Brussels griffons, which appear in several other paintings. According to the artist, the sitter was the child of a friend of Edgar Degas, who himself painted some parts of this work. In particular, Degas' influence can be seen in the asymmetrical composition, the extensive use of pattern, and the cropping of the painting on all four sides, a device both artists admired in Japanese woodcuts.

Joseph Tourny, took place in Cassatt's studio. Degas' reputation as a fierce critic with a sarcastic sense of humor probably matched Cassatt's own opinionated temperament, which in the past had hurt some of her relationships. A close friendship began which lasted until Degas' death in 1917.

Cassatt's decision to abandon the offical path of recognition the Salon had to offer and to pursue her career by joining a notorious, albeit talented group of young artists who gravitated around the central figure of Manet was, perhaps, inevitable, but nevertheless difficult. Becoming a member of the Impressionists meant to publicly denounce the traditional system, abandon the international art community, and immerse herself in this relatively small group of twenty or thirty artists, almost all of whom were French. To make a career as an outsider was risky and some members of the group, in particular Pissarro, lived in dire poverty. Although money was certainly not a critical issue for Cassatt (nor was it for Degas or Manet), her new position was nevertheless a radical departure from her earlier career goals. In addition, she was a woman, although Berthe Morisot, Manet's sister-in-law, was also a member of the Impressionist group, and the two women became very good friends after they

began exhibiting together. Cassatt's frank and open mind and the heritage of her American upbringing eased her access to her male colleagues. On the other hand, for a woman of high moral standards, it was certainly a bold step into a new world when she frequented the society of an artist like Degas, who was known to paint prostitutes.

Like Degas, Cassatt was predominantly a figure painter; other members of the group, such as Monet and Pissarro, were almost exclusively landscape artists. In fact, the group was not homogeneous in its approach to

The Boating Party

detail; 1894, oil on canvas. Chester Dale Collection, National Gallery of Art, Washington, D.C.

The angle formed by the man's arm and the oar leads the eye to the figure of the child, the focus of the entire composition. The brightly colored and striped dresses of the mother and child set them apart from the monochromatic black of the man's outfit. The undulating texture of the water contrasts with the smoothly rendered surface of the wooden boat.

art and represented almost as many different styles as it had members. Their main and common goal, however, was to represent the world as they perceived it with their eyes. Thus, their palettes lightened up, and the play of natural light became an important aspect in their works. The introduction of new, modern subjects, which favored scenes from everyday life over traditional themes from history or mythology (as fostered by the École des Beaux-Arts), also became an important aspect of the new art.

While Cassatt's early artistic development is only sketchily documented, it is obvious that she painted her works at this time with a brighter palette and lighter backgrounds, and that she placed her subjects in relaxed settings. Examples of this new style are her *Self Portrait* and *Little Girl in a Blue Armchair*. The background of the latter painting was in part reworked by Degas himself, who advised Cassatt on various subjects, including the choice of models. The young sitter of the *Little Girl in a Blue Armchair*, for example, was a daughter of a friend of his. Mary also started to carry a sketchbook with her to record spontaneous poses and gestures observed during walks in the city, strolls in the park, or visits at theaters. This exercise helped her to overcome certain mannerisms in her art and to strengthen her drawing skills. She opened her eyes to her surroundings and absorbed the experience of everyday life. By now, she was on her way to becoming a true Impressionist.

Self-Portrait

c. 1878, gouache on paper; 23 1/2 x 17 1/2 in. (59.7 x 44.5 cm).
Bequest of Edith H. Proskauer, 1975,
The Metropolitan Museum of Art, New York.

Only a few self-portraits of Cassatt exist, although she was very conscious of her role as a woman in an art world largely dominated by her male colleagues, in particular by members of the École des Beaux-Arts and the jury of the annual Salon in Paris. The diagonal thrust of her pose reveals an assured personality. Dressed in elegant attire, Cassatt is leaning casually against a cushion, her head slightly turned away from the viewer. The composition and the loosely handled brushwork is reminiscent of works by Edgar Degas.

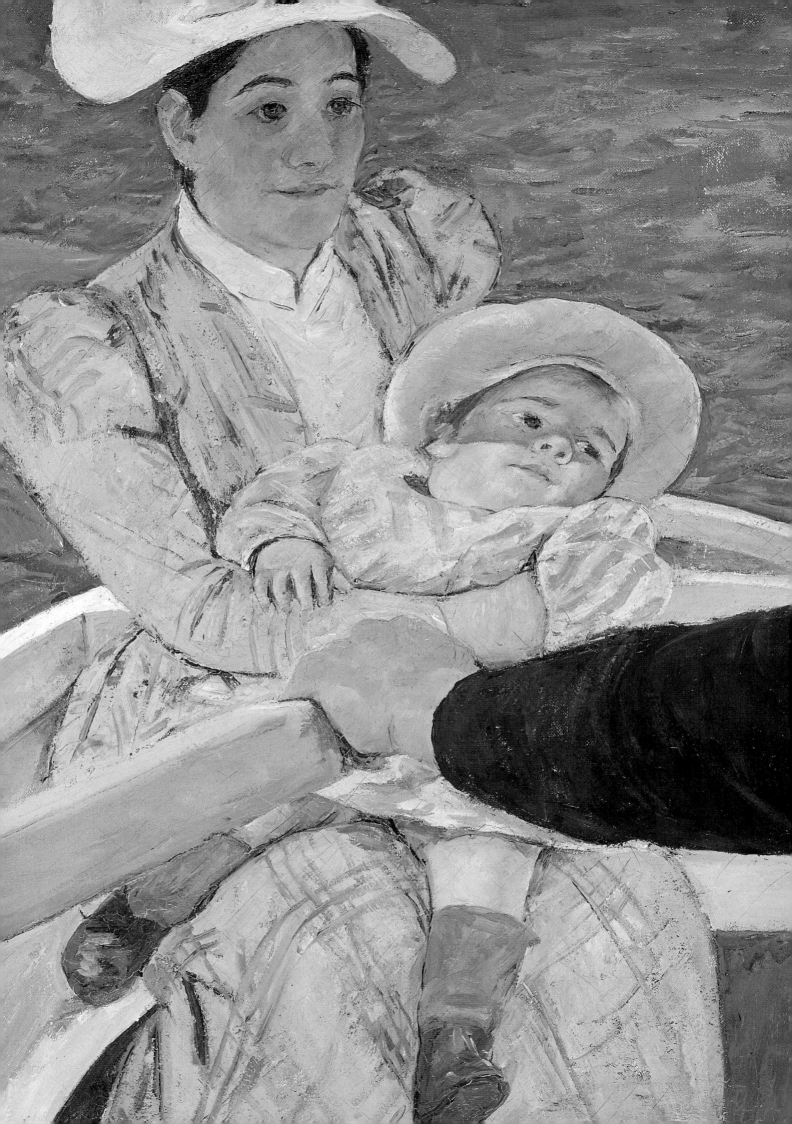

CHAPTER TWO

PARIS AND IMPRESSIONISM

The invitation extended to Cassatt by Degas to join the artistic avant-garde of the Independents, as the group preferred to call itself, was greeted by her with great enthusiasm and anticipation. And in 1912 she told her first biographer, Achille Ségard, "I accepted with joy. Now I could work with absolute independence without considering the opinion of a jury. I had already recognized who were my true masters. I admired Manet, Courbet, and Degas. I took leave of conventional art. I began to live."

Degas and Cassatt

Degas and Cassatt had many traits in common. When they met, Degas was forty-three, ten years her senior. He too came from a wealthy, upper-class family. Both were intelligent and opinionated, sharing the same tastes in art and literature. Both were independent, neither of them married, dedicating their lives to their work. He had studied briefly at the École des Beaux-Arts, but soon began to work on his own, copying Old Masters in France

and Italy. A friend of Manet's, Degas abandoned the art establishment and joined the Independents. His specialty became everyday scenes of the Paris bourgeoisie—opera and ballet, the race course, and cabarets. He was a figure painter, interested in the human body, not a landscape artist like Monet or Pissarro. He never painted outdoors,

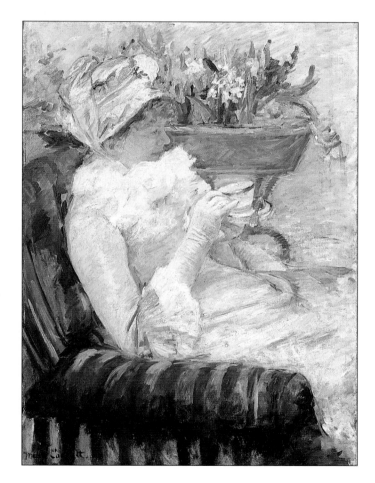

The Cup of Tea

1879, oil on canvas; 36 3/8 x 25 3/4 in. (92.4 x 65.5 cm).
Gift of Dr. Ernest G. Stillman, 1922, from the Collection of
James Stillman, The Metropolitan Museum of Art, New York.
This work was exhibited at the fourth Impressionist exhibition in 1879, when Cassatt was just beginning to make a name for herself. The painting was favorably reviewed by art critics such as Edmund Duranty and Joris K. Huysmans, although Cassatt was generally considered to be a pupil of Degas'. This success seems to have convinced her father of her growing talent and of her determination to make a living as a painter. The model was the artist's sister, Lydia, who, oblivious to the viewer, is calmly sipping her tea in an elegant setting.

Susan on a Balcony Holding a Dog

detail; c. 1882, oil on canvas;
The Corcoran Gallery of Art, Washington, D.C.
The purple hues of the Montmartre rooftops, seen from the artist's apartment in Paris, are reflected in the white hat of the model, thus binding the figure into the surrounding environment. Views from balconies onto the streets are common among Impressionist painters. Cassatt, however, was never interested in depictions of urban scenes, and this is her only attempt.

Following page:
Katherine Cassatt Reading to Her Grandchildren
(Eddie, Elsie and Katherine)
1880, oil on canvas; 22 x 39 1/2 in. (55.9 x 100.3 cm). Private collection, New York.
As with other interiors, the artist has focused on the interaction between the sitters rather than on a careful depiction of the surrounding environment. Here Mrs. Cassatt, the painter's mother, is sitting near a window reading to her grandchildren from one of a series of French children's books called *La Bibliothèque Rose*. At the lower right, Katherine, seen from the back, is drawing the viewer into the picture. Her glance passes by her grandmother to meet her sister Elsie's eyes on the other side. Eddie is depicted in profile and faces his grandmother frontally, thus completing the circle.

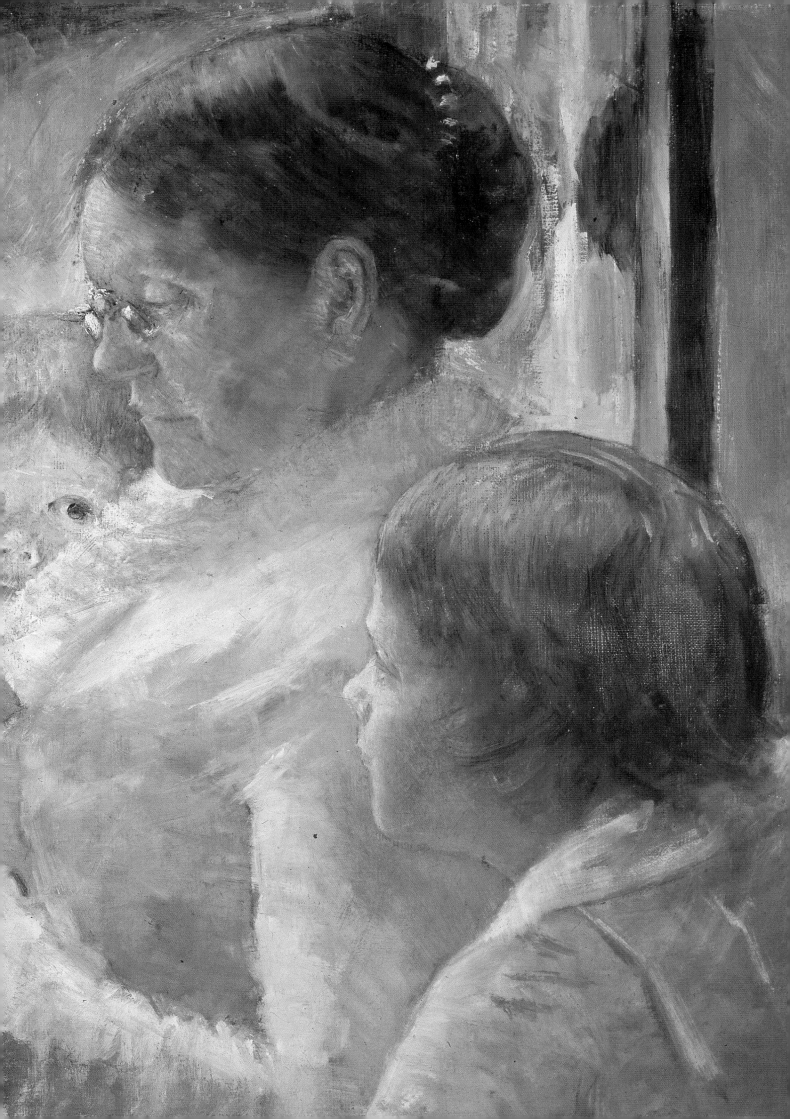

Reading *Le Figaro*

1878, oil on canvas; 39 1/16 x 34 1/2 in. (104 x 83.7 cm). Private collection, Washington, D.C.
This portrait of the artist's mother is one of Cassatt's finest achievements in the genre. Mrs. Robert Simpson Cassatt is shown
engaged in one of her favorite activities, reading the newspaper, in this case *Le Figaro*. The curvilinear forms of the woman's
head and shoulders and the back of the chair respond to the rectangular shapes of the mirror and the edges of the newspaper. The
reflections in the mirror are effectively employed to open the confining background and to introduce an ambiguous quality of space.

but preferred to work in his studio. Cassatt took on his interests and approach, and, for some time, even his style.

But their friendship did not remain completely unclouded. As Cassatt later reported, they were often at odds and separated: "Oh, I am independent! I can live alone and I love to work. Sometimes it made him furious that he could not find a chink in my armor, and there would be months when we just could not see each other, and then something I painted would bring us together again and he would go to Durand-Ruel's and say something nice about me, or come to see me himself." One might speculate as to whether or not the two artists had a more intimate affair, but this seems to have been unlikely given their strong moral stands and conservative upbringings. Their relationship was instead based on mutual respect and admiration, even though it may well have been a rather emotional alliance.

Among Family

Another important factor in Cassatt's life at this time was the continuing presence of her family. In the fall of 1877, her parents came to Paris to live with her permanently. The reason for this decision is not clear, but it is possible that Mary herself had proposed this idea. She certainly enjoyed having her family around her, and soon they moved to a new apartment on the top floor of a building at 13 Avenue Trudaine which overlooked the Montmartre hill (as seen in *Susan on a Balcony Holding a Dog*). Cassatt continued to keep her studio nearby, which for the first time lay outside her living quarters. What she did not foresee perhaps were the new restrictions which such a family life invariably presented. The companionship of her older sister Lydia, however, outweighed, or at least tempered, some of these disadvantages. Lydia, unmarried and suffering from an undiagnosed disease, was homebound, and frequently served both as Mary's companion and as a model for her paintings.

Soon after her parents' arrival Cassatt began the portrait of her mother, *Reading "Le Figaro,"* which shows Mrs. Cassatt reading the French daily newspaper. This painting illustrates her newly achieved style with its dominant Impressionistic features, such as a light palette, dense brushwork, the casual realism of the subject matter, and an asymmetric cropping of the pictorial space. The painting was intended as a token of remembrance for Cassatt's brothers back in Philadelphia.

The fourth Impressionist exhibition, planned for the summer of 1878, was postponed for organizational reasons until April of the following year. This delay gave Cassatt more time to prepare for her first showing with the Independents. In the meantime, she sent pictures to exhibitions in New York, Philadelphia, and Boston, since the link with galleries and collectors in the United States

was important to her. The meager results in terms of sales, however, were disappointing. It was not until the beginning of the next century that her work received a stronger response and acceptance in her native country.

The Fourth Impressionist Exhibition

The fourth Impressionist exhibition took place without the participation of some of the group's founding members. Renoir, Sisley, and Cézanne all decided to submit to the Salon—which disqualified them automati-

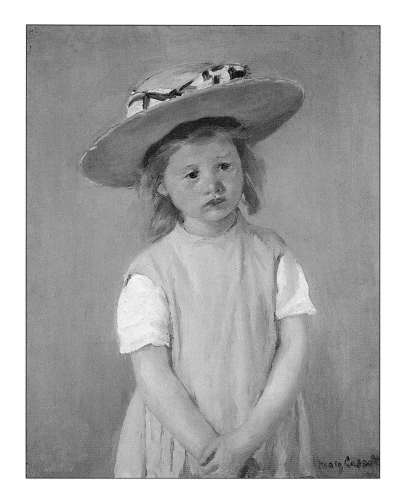

Child in a Straw Hat

c. 1886, oil on canvas; 25 3/4 x 19 1/2 in. (65.4 x 49.5 cm).
Collection of Mr. and Mrs. Paul Mellon, National Gallery of Art, Washington, D.C.
The simplicity of the girl's pose and dress is reflected in her melancholy expression. Her state of mind seems to be underscored by the choice of dull colors: a gray dress over a white shirt, a pale yellow straw hat with a black-and-white ribbon, and the grayish-brown background. Portraits of children alone are rare during this period of Cassatt's career. This work marks the transition from the Impressionistic style towards a more restrained and compact rendering of her subjects.

Profile Portrait of Lydia Cassatt (the artist's sister)

1880, oil on canvas; 36 1/2 x 25 1/2 in. (93 x 66 cm).
Musée du Petit Palais, Paris.

Sitting on a park bench, Lydia Cassatt is wearing a colorful dress in the scheme of a rich autumn foliage. Bold strokes of predominantly red and golden tones form a vibrant pattern of crisscrossing lines, while her black hat (with a red rim) and a black scarf balance the liveliness of these colors. A green bench is placed diagonally into the picture space as if the viewer is approaching the woman on a path coming from the right. This immediacy is taken back, however, by her composed attitude and her apparent lack of interest in the intruder.

cally from the Impressionist show—but only Renoir was accepted. This weakness notwithstanding, the exhibition turned out to be the most successful of the Impressionist shows thus far. About sixteen thousand visitors came to see the works, and the artists even made a small profit from the proceeds of the ticket sales. Cassatt immediately bought some works by Monet and Degas with her share of the earnings.

The show was arranged in an apartment near the Opéra which was rented for the occasion. The location was well chosen, as the locale was in the same elegant district that also housed the major art galleries, including that of Durand-Ruel, who had "discovered" the Impressionists. As usual Degas was instrumental in the practical details of the show's organization. After he had found the rooms, as one critic described the process, "M. Degas gives a sign to his companions. The interior decorator is informed immediately. As many works are collected as a drawing-room, a dining-room, two bedrooms, a bathroom, and a kitchen could contain. A turnstile is installed in the anteroom and the day for the opening is fixed."

Cassatt was privileged to have her works hung in a unified grouping. She exhibited eleven

EDGAR DEGAS (1834–1917)
Portrait of Mary Cassatt

c. 1880–1884, oil on canvas; 28 1/8 x 23 1/8 in. (71.4 x 58.7 cm). Gift of the Morris and Gwendolyn Cafritz Foundation and the Regents Major Acquisition Fund, National Portrait Gallery, The Smithsonian Institution, Washington, D.C.

Edgar Degas, the artist's closest male friend and admired colleague, presumably painted this portrait in exchange for a work by Cassatt. She is seen sitting on a chair leaning forward, holding tarot cards in her hands like a fortune teller. In later years, Cassatt admitted her dislike for this work, probably because of the informal pose she was given. Nevertheless, it documents the intense and fruitful artistic relationship between the two painters.

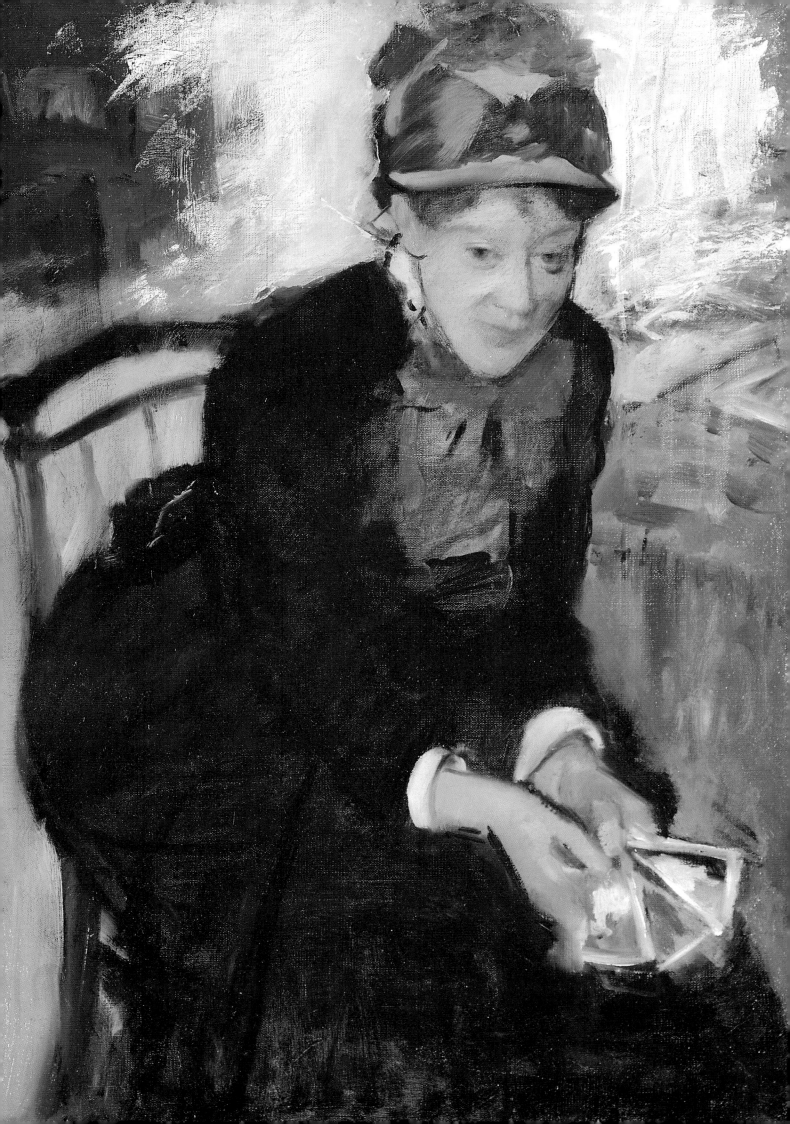

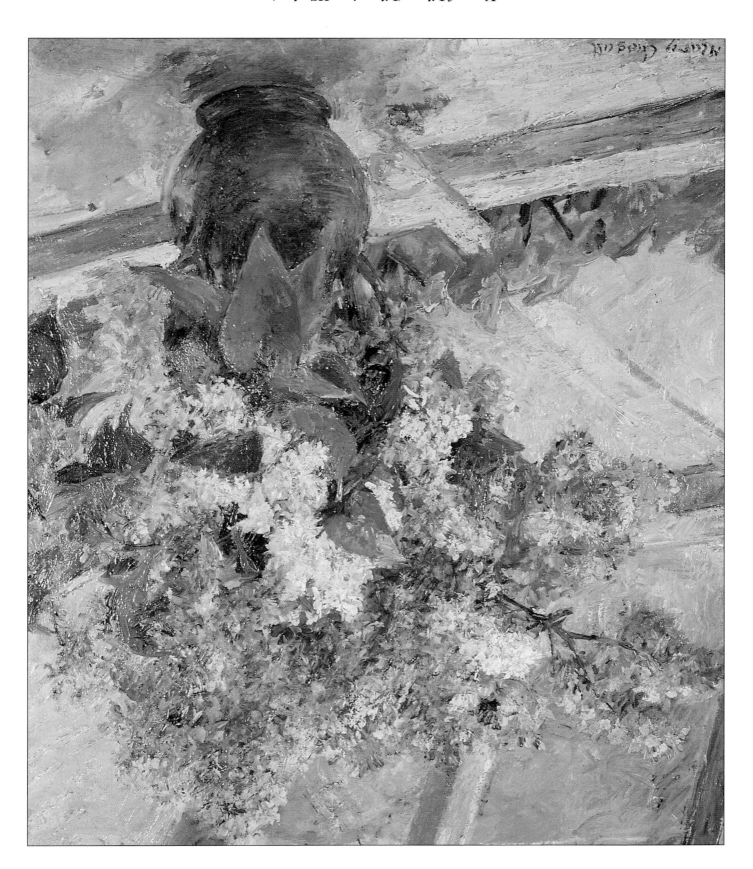

Vase of Lilacs (Lilacs in a Window)
c. 1880, oil on canvas; 24 1/2 x 20 in. (61.6 x 51 cm). Private collection.

Still lifes are rare in Cassatt's oeuvre, which is overwhelmingly dominated by figure paintings. Perhaps inspired by Manet's late flower still lifes (painted around the same time), Cassatt captured the fluffy texture of the lilacs and the light playing on the surface of their petals with infinite small brushstrokes in a purely Impressionistic technique.

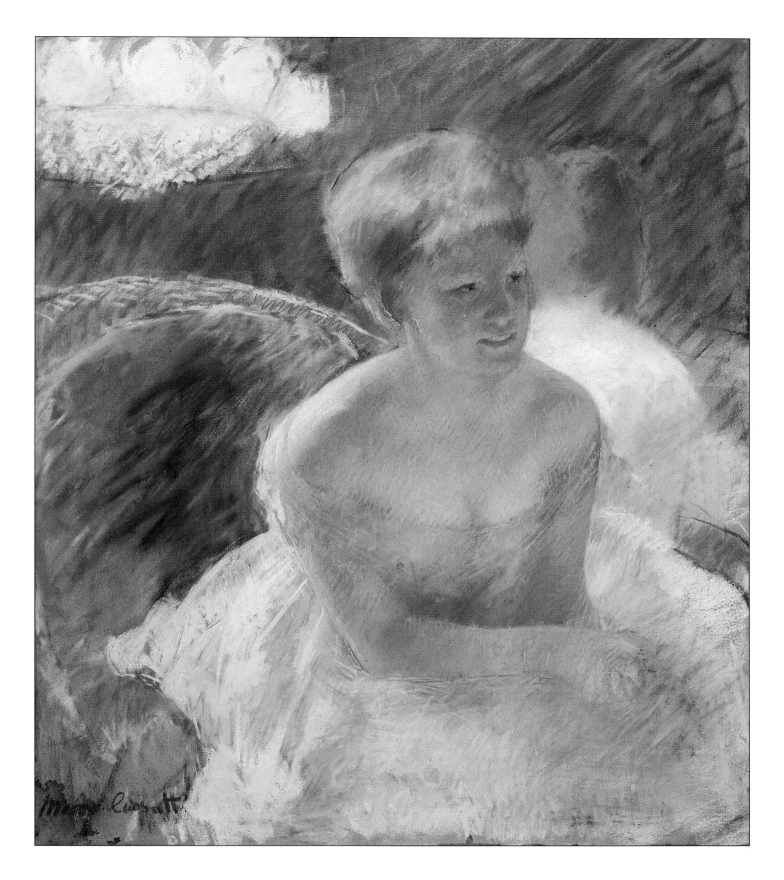

At the Theater (Woman in a Loge)
1879–1880, pastel on paper; 21 5/8 x 17 3/4 in. (54.9 x 45.1 cm). The Nelson-Atkins Museum of Art, Kansas City, Missouri.
The artist's sister, Lydia, served as the model for this pastel. The loose pastel strokes are applied in a nervous, agitated manner similar to Degas' technique, achieving shimmering effects of light playing over richly textured surfaces. In Cassatt's oeuvre, the subject of women in theaters reveals the importance and excitement of a form of entertainment enjoyed by a well-to-do Parisian class that included the artist and her family.

oils, pastels, and gouaches which occupied the third room of the gallery, thus forming a small one-woman show. They included scenes of women at the theater or in a drawing room, modern subject matters that were clearly influenced by Degas. These new pictures were quite different from her Spanish period or her Rubenesque peasant paintings with which she had hoped to win a Salon medal only a few years earlier. Now, however, Cassatt belonged to the avant-garde movement which was slowly beginning to be received more positively by the public. Over thirty notices or reviews appeared in Paris newspapers alone. One critic made particularly positive comments about Cassatt's works: "There isn't a painting, nor a pastel by Mlle. Mary Cassatt that is not an exquisite symphony of color. Mlle. Mary Cassatt is fond of pure colors and possesses the secret of blending them in a composition that is bold, mysterious, and fresh." Another critic noted her relationship to Degas:

> **M. Degas and Mlle. Cassatt are perhaps the only artists who distinguish themselves in this group of "dependent" Independents, and who give the only attractiveness and excuse to this pretentious display of rough sketches and childish daubs, in the middle of which one is almost surprised to come across their neglected works. Both have a lively sense of the fragmented lighting in Paris apartments; both find unique nuances of color to render the flesh tints of women fatigued by late nights and the rustling lightness of worldly fashions.**

This success seems to have convinced Mr. Cassatt of his daughter's seriousness and of her accomplishments. He sent newspaper clippings of the reviews to his sons in Philadelphia with a mix of pride and surprise. Naturally, there were the usual bad reviews and condemnations which had also accompanied the previous exhibitions. Many of these rebukes were aimed at Mary Cassatt: "A poor young woman, very far gone with the Jaundice wash shown wrestling with her fan in the depths of an opera-box. We cannot in fact understand the purpose of the new school. . . . We can see in it only the uneasy striving after notoriety of a restless vanity, that prefers celebrity for ill doing rather than an unnoted persistence in the path of true art." Only two years earlier Cassatt

Profile Portrait of Lydia Cassatt (the artist's sister)
detail; 1880. Musée du Petit Palais, Paris.
Broad vigorous brushstrokes build up the intricate patterning of Lydia's dress. A devoted admirer of textiles and herself a competent tailor, Lydia often shopped for fabrics in the elegant stores of Paris, accompanied by her family or visiting relatives.

The Loge
c. 1880, oil on canvas; 31 1/2 x 25 1/8 in. (79.9 x 63.9 cm),
Chester Dale Collection, National Gallery of Art, Washington, D.C.
Judging from the hesitant, self-conscious expression on their faces, these two young women appear to be at the theater for the first time. Absorbed with keeping their pose and clasping their accessories—one is holding a bouquet of wrapped flowers while the other seems to be concealing an untimely yawn behind her fan—these women are not comfortable with the yet unfamiliar exposure in a public environment.

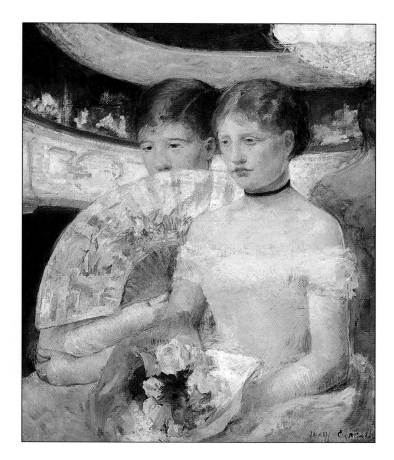

would have been stung by such a critique. Now, she was able to dismiss it as irrelevant.

The Cassatt family enjoyed going to the theater on a regular basis. Once or twice a week they attended performances at the classic theater, the Opéra Comique, or the famous Cirque Fernando located in their neighborhood, to which they often took children of their acquaintance, including Mary's models. Unlike Degas, Mary Cassatt did not focus her attention on the performers, but rather on the audience, especially on young women in beautiful dresses nervously holding such paraphernalia as fans, bouquets of flowers, gloves (*The Loge*), or

binoculars (*At the Opéra*). Her models were taken from real life even when the paintings were actually carefully composed in her studio.

Between 1879 and 1882 the Independents held their group exhibitions annually, thus providing Cassatt with the much desired opportunity to show her work, since she did not have a Paris dealer at that time. In the United States she was now exhibiting regularly with the Society of American Artists in New York. The informal network among the Impressionists and the Parisian intellectuals had already provided her with a number of clients, including the collector Moïse Dreyfus, for whom she executed a portrait (*Portrait of Moïse Dreyfus*).

Le Jour et la Nuit

Celebrating her latest success, Cassatt went on a trip to northern Italy with her father. Upon their return to Paris in the fall she embarked on a new project, with Degas, Pissarro, and others, to launch a new art journal illustrated by their own etchings. The initiative came from Degas, who planned to call the publication *Le jour et la Nuit* (*Day and Night*). It was to have featured short stories and essays by avant-garde writers alongside the artists' etchings. Much to Cassatt's chagrin, the project was eventually abandoned, but some important prints were produced. Furthermore, Cassatt had acquired sufficient skills as a graphic artist to inspire her to proceed independently in this new medium. The value of her training with Carlo Raimondi in Parma suddenly became evident, and

the graphic reproduction of two of her paintings in another art journal may well have opened her eyes to the possibility of a wider range of distribution for her works. When her father sent a copy of this journal, *La Vie Moderne* (*The Modern Way*), to Philadelphia, he included this comment: "The sketch does not do justice to the picture which was original in conception & very well executed—and was as well, the subject of a good deal of controversy among the artists & undoubtedly made her very generally known to the craft."

In any case, it was certainly preferable for Cassatt to produce her own engravings rather than seeing them done by less talented commercial engravers. She continued to practice her graphic skills by executing drypoints, a technique that required precise dexterity while drawing directly on a copper plate. "In drypoint, you are down to the bare bones, you can't cheat," Cassatt observed. The new importance she placed on draftsmanship was shared by Degas, who always remembered Ingres' words to him when still a student: "Draw lines, young man, many lines . . . it is that way that you will become a good artist."

Although the planned art journal fell through because Degas "was not ready," the time Cassatt spent with him working side by side using the printing equipment in his studio was a productive one for her. Many times her sister Lydia came along to pose for Degas, as did Cassatt herself on occasion "when he finds a movement difficult, and the model cannot seem to get his idea," as she later told her friend Mrs. Havemeyer. Although neither

Woman and Child Driving

1881, oil on canvas; 35 1/4 x 51 1/2 in. (89.3 x 130.8 cm). The W. P. Wilstach Collection, Philadelphia Museum of Art, Philadelphia.

Here the artist depicted her sister Lydia driving a cart recently acquired by the Cassatt family. Next to her sits Odile Fèvre, a niece of Degas', the youngest daughter of his sister Marguerite. The groom behind them is facing the opposite direction. The scene is severely cropped and compressed, thus achieving the intimacy of a fleeting moment as in a photographic snapshot. The greenery of the Bois de Boulogne in the outskirts of Paris serves merely as a backdrop for the figures.

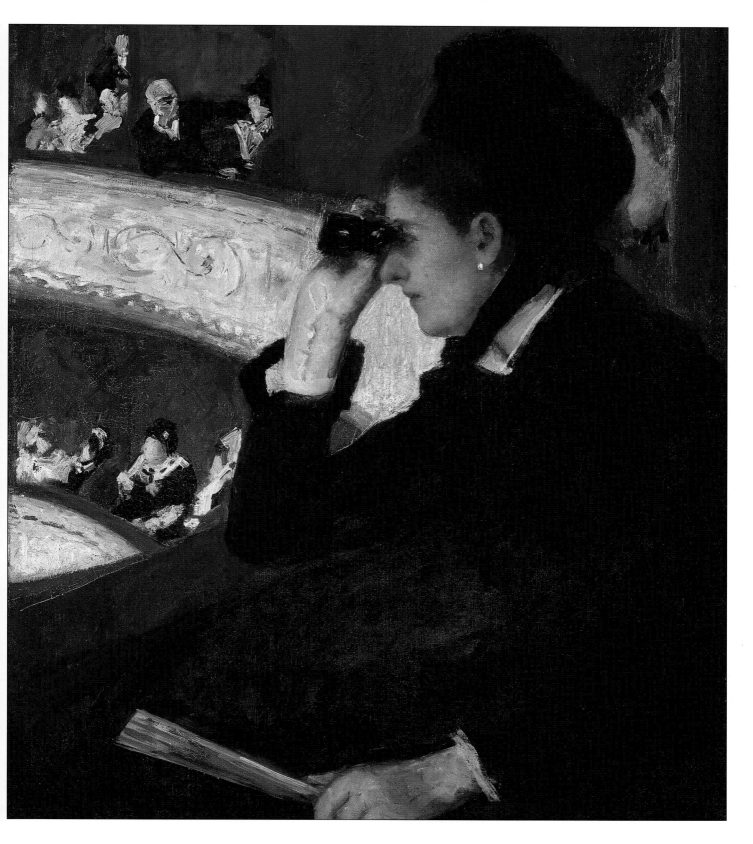

At the Opéra

1879, oil on canvas; 31 1/2 x 25 1/2 in. (80 x 64.8 cm). The Charles Henry Hayden Fund, Museum of Fine Arts, Boston.
Unlike most of Cassatt's other loge pictures, this painting of a woman attending a performance at the Paris Opéra does not
include a mirror reflection. The subject is gazing through binoculars into the empty space of the theater, but whether her
curiosity is absorbed by the activity on the stage or merely by an attractive crowd of elegant spectators can not be determined.
A humorous touch is added by the figure of the man in a background box who, in turn, is scrutinizing the woman through
his glasses. A similar use of rich and varied blacks can be found in theater paintings by Edouard Manet and Eva Gonzàlez.

woman can be considered a beauty, their features and character were distinct and captivating. In a well-known etching, *The Etruscan Gallery*, Degas used both women as models. Often the two artists socialized at public gatherings; Degas frequently dined with the Cassatts and invited them to his own soirées. He even gave Mary a thoughtful present, a Brussels griffon puppy, which he obtained through their common friend, Ludovic Lepic. The dog accompanied Cassatt almost everywhere and can be seen in *Susan on a Balcony Holding a Dog*.

The Fifth Impressionist Exhibition

Not only was the failure of the art journal a disappointment for Cassatt, but the fifth Impressionist exhibition, held in April of 1880, was also less successful than the previous one. Once again Renoir, Sisley, and Cézanne defected from the group, and this time, so did Monet. Although their absence made it easier for Cassatt to stand out from the other participants, the show lacked the depth it had enjoyed in the past. Notwithstanding these difficulties, some encouraging reviews revived her spirits. Joris K. Huysmans, for example, while noting Degas' influence, stated that "Miss Cassatt has nevertheless a curiosity, a special attraction, for a flutter of feminine nerves passes through her painting which is more poised, more calm, more able than that of Mme. [Berthe] Morisot." Paul Gauguin, who also exhibited with the group that year, noted that "Miss Cassatt has as much charm [as Morisot], but she has more power."

In September of 1880 Alexander Cassatt, Mary's brother, arrived in Paris with his family. Cassatt took the opportunity to paint the children with their grandmother during a stay in their country house at Marly-le-Roi (*Katherine Cassatt Reading to Her Grandchildren*). She also used Lydia as her model with increasing frequency; during the same summer Cassatt painted *Lydia Crotcheting in the Garden at Marly*, en plein air (out of doors), showing her sister engaged in one of her favorite needlework activities. The freshness and naturalness of the subject and the handling of the light are representative of Cassatt's Impressionist style. More works soon followed—*Lydia Working at a Tapestry Loom* and *The Cup of Tea*—in which Lydia appears in urban apartment settings.

At least three of the of eleven works seen at the Impressionist exhibition in 1881 featured Lydia Cassatt. The critic Gustave Geoffrey, who was impressed by *The Cup of Tea*, wrote: "We prefer above all the woman in the pink dress and bonnet who holds a cup of tea in her gloved hands. She is exquisitely Parisian. The nuances in the pink, the airy lace, and all the lights and reflections that play upon her clothing, hair, and softly pale skin make the *Thé* a delicious work." *Lydia Crocheting in the*

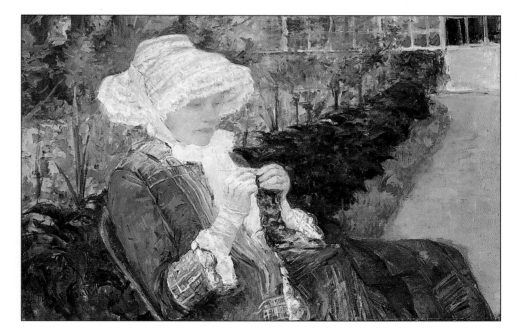

The Cup of Tea
detail; 1879. Gift of Dr. Ernest G. Stillman, 1922, from the Collection of James Stillman, The Metropolitan Museum of Art, New York.
Mary Cassatt was known for precious arrangements at receptions in her Paris apartment, where selected food and wines were served on fine porcelain and in crystal glasses. This detail captures such a moment: The woman's silk-gloved hand lifts a white china cup decorated with a golden rim which glistens together with the silver spoon in the bright light.

Lydia Crocheting in the Garden at Marly
1880, oil on canvas; 26 x 37 in. (66 x 94 cm). Gift of Mrs. Gardner Cassatt, 1965, The Metropolitan Museum of Art, New York.
This portrait of Lydia shows her doing needlework in the garden of a house at Marly-le-Roi (near Paris), which the Cassatt family had rented for the summer of 1880. Mary chose a peaceful moment in the life of her older sister, already suffering from the disease which would cause her untimely death two years later. By accident, the ailing Edouard Manet was the Cassatt family's neighbor during the same period.

Lydia at a Tapestry Loom

c. 1881, oil on canvas; 25 3/4 x 36 1/4 in. (65.5 x 92 cm). Gift of the Whiting Foundation, Flint Institute of Arts, Flint, Michigan. One of the last portraits of the artist's sister Lydia, who died in 1882, shows her working at a tapestry loom. Sunlight, filtered through a transparent curtain, is entering the room from the vaguely defined background at the left. The space is divided diagonally by the prominently displayed tapestry frame behind which Lydia is completely absorbed in her work. This abrupt division is used as a means of bringing the viewer into the picture plane, a technique Cassatt learned from Japanese woodcuts.

Garden at Marly was praised by another reviewer, who commented: "Among [the works] I especially like her woman seated outdoors with knitting in her hands. Shaded by a large white bonnet, her face has a lovely tonality that is simple and peaceful." Since Cassatt treated all her works as part of her professional output it usually did not make much of a difference if her models were members of her own family. She was equally willing to sell these paintings as long as they served to achieve her goal of gaining fame and fortune.

Moving On

The following year was full of setbacks, both personal and professional. Conflicts among the members of the Impressionist group caused Degas to pull out from the annual exhibition. Although Cassatt was still invited to show, she demonstrated loyalty towards her mentor by also refusing to exhibit. At the end of 1882, Lydia Cassatt died of Bright's disease. This loss was felt even more strongly by Cassatt since she had planned to grow old together with her sister. Furthermore, her parents were aging rapidly. Her mother's declining health forced her to look for a new apartment where she did not have to climb up five flights of stairs. Cassatt started to look for closer ties with old and new friends including Berthe Morisot and her husband, Eugène Manet, Camille Pissarro, Auguste Renoir, the poet Stéphane Mallarmé, and, occasionally, the Socialist politician Georges Clemenceau or other intellectuals.

Without the pressure of Impressionist exhibitions between 1882 and 1886, Cassatt lacked incentive to produce paintings and etchings with the same regularity as in past years. The art market in Paris had suffered for several years from a bad economy. In 1885, Durand-Ruel organized a major exhibit which was to introduce Impressionism on a large scale for the first time in New York. For the new show Cassatt's brother Alexander lent her the only two works that represented her Impressionist style, *Katherine Cassatt Reading to Her Grandchildren* and *Reading "Le Figaro,"* both of which dated back to previous years. At the same time, the last Impressionist show to take place in Paris opened with much less fanfare than in the past. Attendance was not as good as in previous years, and after the closing of the show there was no talk of another one. It was, in fact, the last of its kind.

Cassatt had already begun to leave the Impressionist style behind her and to produce more solid works which no longer had the spontaneous immediacy of her earlier theater scenes and interiors. Furthermore, the art market seemed to focus more on Monet, Degas, and Renoir, relegating the other Impressionist artists to a second rank of the movement. In addition, a younger generation centering around the figures of Seurat and Signac had begun to show their new works painted in the Neo-Impressionist style, which utlized scientific color schemes. Cassatt's interests were leading her in other directions, towards an artistic language of her own.

Self-Portrait

c. 1880, watercolor on paper; 13 x 9 5/8 in. (33 x 24.4 cm). The Smithsonian Institution, National Portrait Gallery, Washington, D.C. In this lively and spontaneous self-portrait, only the head and the torso of Cassatt's body have been clearly defined. The casualness of the rendering, however, belies the self-awareness and self-determination which characterized Cassatt's personality throughout her life. Part of the paper has been left white and several brushstrokes were added with quick, informal gestures. Nevertheless, the fact that she signed the work with her initials demonstrates that she must have considered it finished.

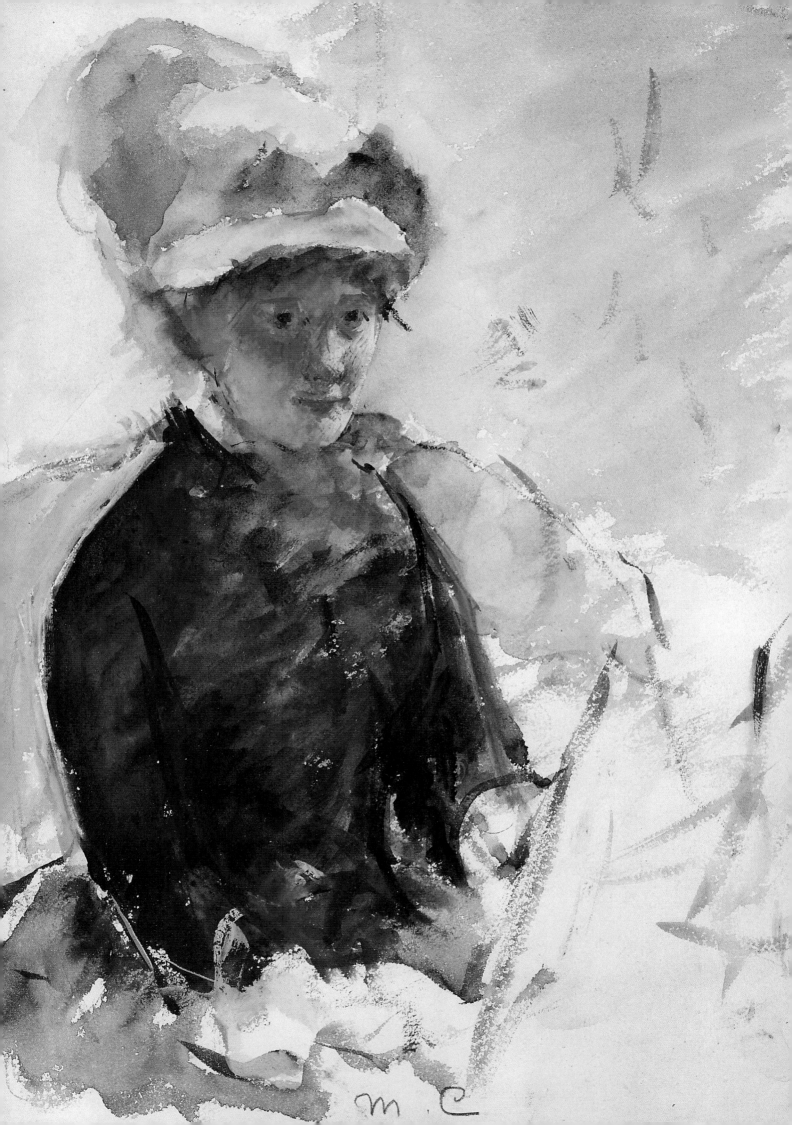

PORTRAITS AND PRINTS

*A*s the sitters are often known, many of Cassatt's works can be considered portraits, although the artist rarely painted them with the principal intent of producing a close likeness. She was instead interested in creating an atmosphere around her subjects and in showing the sitter's emotions and moods, which she expressed with the subtleness of her artistic language. Her work differed from the stiff academic tradition of portrait painting as a mere likeness insofar as most of her subjects were either engaged in some kind of activity or caught in a casual pose.

Lady at the Tea Table

In the fall of 1883 Cassatt painted a portrait of Mrs. Annie Riddle Scott, her mother's first cousin, in return for a gift of a precious Japanese tea set. The work became known as *Lady at the Tea Table*, suggesting that Cassatt did not want to stress that the sitter was the main feature in this painting even though it was clearly intended as a portrait. In fact, the painting is both a portrait and a genre scene, including the stunning still life of the tea set in the Canton style. The composition conveys a sense of order and control through the silhouetted shape of the woman's body concealed in a dark blue dress. Her neatly parted hair is partially covered with a pale yellow scarf. The vertical and horizontal lines of the wainscoting and the picture frame in the background add to the monumental calm of this work, which is enlivened by the detailed rendering of the woman's right hand grasping the teapot on the table in front of her. The still life of the porcelain set is a masterly display of

Lady at the Tea Table
detail; 1883. Gift of the artist, 1923,
The Metropolitan Museum of Art, New York.
Japanese art was at the height of its popularity in Europe
when the Cassatt family received this precious tea set as a
gift. The blue and gold decoration on a white background is
rendered with dabs of great liveliness and an appreciation
of the material that includes the effects of light on its surface.

luminous effects in blue, white, and gold. Degas called this portrait "distinction itself," but Mrs. Cassatt, the artist's mother, wrote in a letter to her son Alexander, "Mary asked Mrs. Riddle to sit for her portrait thinking it was the only way she could return their kindness. . . . As they are not very artistic in their likes & dislikes of pictures & as a likeness is a hard thing to make to please the nearest friends I don't know what the result will be—" Her premonition turned out to be correct.

Mrs. Riddle, who was a legendary beauty in her youth in Philadelphia, did not like the portrait. It remained in the artist's studio for the next thirty years until Cassatt exhibited it in 1914 to great acclaim. In 1923, a few years before her death, she donated the painting to The Metropolitan Museum of Art in New York.

At the close of 1884 and into early 1885, during a visit to Paris by her brother Alexander and his family, Cassatt painted a double portrait of him together with his son Robert Kelso (*Portrait of Alexander Cassatt and His Son Robert*). This portrait is another example of her severe style. The dark suits worn by the father and son while sitting close together in an armchair seem to merge, and the similarity between the two faces with their dark eyes is striking. Just as the spontaneity of earlier works was the result of concentrated efforts, here Cassatt made an effort to achieve a state of calm and poised equilibrium.

Young Woman in a Garden

Two paintings which were created more as genre scenes are *Young Woman in a Garden* and *Girl Arranging her Hair*. The first one was painted shortly after Lydia Cassatt's death and shows a young woman sewing outside in a garden. The model appears to have replaced Lydia and is also featured in other works, always engaged in various types of needlecraft. Although not a portrait in the traditional sense of the term, the woman's pose, the attention which she devotes to her work, and the simplicity of the composition convey to the viewer more about the sitter's personality than a straightforward likeness would have done.

The same might be said about *Girl Arranging her Hair*. Almost thirty years

Portrait of Alexander Cassatt and his Son Robert
1885, oil on canvas; 39 1/2 x 32 in. (100.3 x 81.3 cm). W. P. Wilstach Collection, Philadelphia Museum of Art, Philadelphia.
Named after his uncle who had died in his childhood, Robert Kelso was about fourteen years old when painted together with his father, Cassatt's older brother Alexander, during their stay in Paris. A tight bond between father and son is evident from the close pose of the sitters, whose features show strong resemblances. Alexander's face seems to express confidence and pride (he was a successful businessman with the Pennsylvania Railroad), while his son shows the affection of a loving child.

Young Woman Sewing in a Garden
c. 1883–1886, oil on canvas; 36 x 25 1/2 in. (91.5 x 64.7 cm). Musée d'Orsay, Paris.
The women in Cassatt's paintings frequently pursue activities traditionally reserved for them by society. Here, a young woman is seen in a sharply foreshortened perspective, bending her head slightly over her needlework. She is sitting in a garden chair with her legs crossed, amid a group of bright red flowers.

A sandy path cutting obliquely through the background divides the picture into two uneven parts. The flattening of space was a device that the artist derived from Japanese prints.

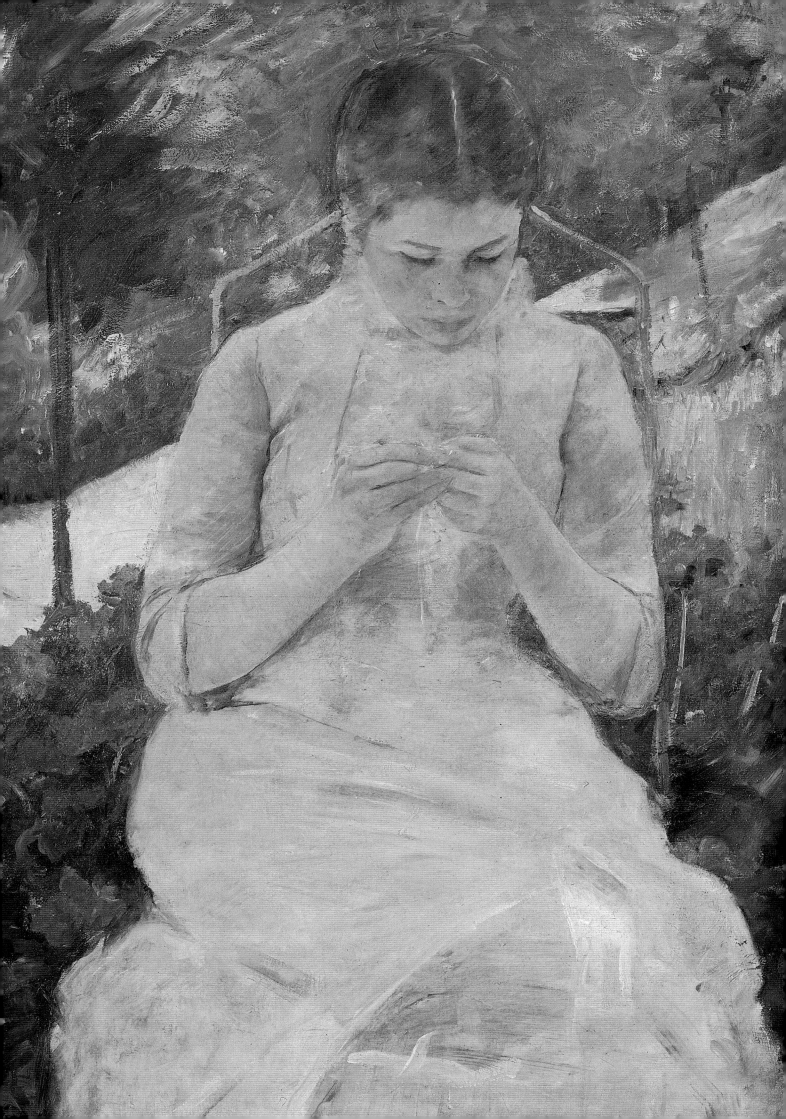

later, Cassatt's biographer, Achille Ségard, described the incident which lead to this painting:

> The story is that one day, in front of Degas, Miss Cassatt in assessing a well-known painter of their acquaintance dared to say: "He lacks style." At which Degas began to laugh, shrugging his shoulders as if to say: These meddling women who set themselves up as judges! What do they know about style.
>
> This made Cassatt angry. She went out and engaged a model who was extremely ugly, a servant-type of the most vulgar kind. She had her pose in a robe next to her dressing table, with her left hand at the nape of her neck holding her meager tresses while she combed them with her right, in the manner of a woman preparing for bed. The model is seen almost entirely in profile. Her mouth hangs open. Her expression is weary and stupid.
>
> When Degas saw the painting, he wrote to Miss Cassatt: What drawing! What style!

This description captures some of the key elements of this painting, to which one might add the bravura effects of the light reflected on the girl's robe and on the objects placed behind her on the dressing table. Wedding beauty with ugliness was also characteristic of Degas, whose depictions of women often combine heterogeneous elements. While such effects did not always please the general public, they became one his infamous trademarks. Cassatt, who was invariably impressed by her mentor's aesthetics, followed him in this direction too, perhaps sens-

ing that it might further her acceptance among the Impressionist circle.

Looking Beyond Beauty

In the mid-1890s Cassatt frequently chose to engage unattractive models with plebeian features and to place them in heroic roles. One of them, a woman named Clarissa, who had a robust figure and a broad, round face with a strong neck, appears in *Clarissa with a Fan* and

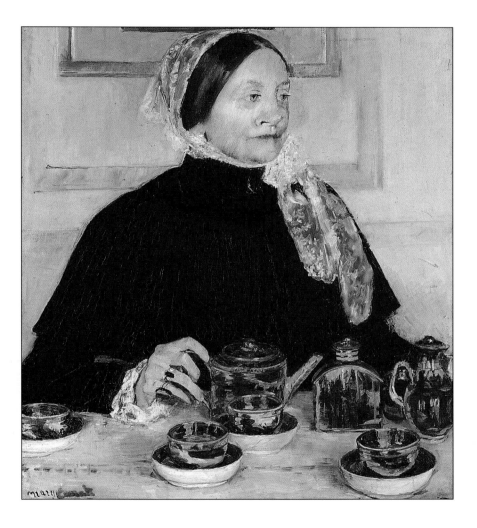

Girl Arranging Her Hair

detail; 1886. Chester Dale Collection,
National Gallery of Art, Washington, D.C.
The detailed rendering of light effects which Cassatt had learned from the Impressionists can easily be discerned in the white highlights of the girl's gown and the reflections on the carafe on the washstand. Respecting the different quality of the materials, the artist chose broader brushstrokes for the fabric and a smoother handling of paint for the surface of the crystal.

Lady at the Tea Table

1883, oil on canvas; 29 x 24 in. (73.4 x 61 cm). Gift of the artist, 1923,
The Metropolitan Museum of Art, New York.
Mary Dickinson Riddle, first cousin of the artist's mother, is shown with a Japanese porcelain tea set, presented to the Cassatt family by the sitter's daughter, Annie Riddle Scott. This explains the careful attention given to the arrangement of the silhouetted shapes of the still life displayed on the table. The portrait was intended to reciprocate for the splendid gift. Mrs. Riddle, however, disliked the painting which shows her—once considered a beauty in Philadelphia—with an aged face. Stored away in a closet until 1914 when it was exhibited to great acclaim, the painting was given to The Metropolitan Museum of Art by the artist in 1923.

Louisine Elder Havemeyer

1896, pastel on paper; 29 x 24 in. (73.6 x 60.9 cm).
Shelburne Museum, Shelburne, Vermont.

Since their first encounter in Paris in the summer of 1874, Cassatt and Louisine Elder Havemeyer had become close friends. Advised by Cassatt in matters of art and collecting, over the years Mr. and Mrs. Havemeyer purchased an extraordinary group of Old Masters as well as Impressionist paintings. In fact, Mrs. Havemeyer acquired the first Impressionist work ever to enter an American collection, a pastel by Edgar Degas.

various other works. To criticism voiced against such drastic features Cassatt responded in a letter to a friend with characteristically strong words:

> **So you think my models are unworthy of their clothes? You find their types coarse. I know that is an American newspaper criticism, everyone has their criterion of beauty. I confess I love health & strength. What would you say to the Botticelli Madonna in the Louvre. The peasant girl & her child are clothed in beautiful shifts & wrapped in soft veils. Yet as Degas pointed out to me Botticelli stretched his love of truth to the point of painting her hands with the fingernails worn down with field work!**

That Cassatt never flattered her sitters becomes evident also in the portrait of *Louisine Elder Havemeyer*. Her broad face with the pronounced front is framed by the puffed sleeves of a dress which adds to the monumentality of her commanding pose. The two women had met in Paris in 1874 through a common friend, when Louisine Elder (who was to marry Harry Havemeyer in 1883) was only nineteen years old. Deeply impressed by Cassatt's captivating personality, she noted: "I felt then that Miss Cassatt was the most intelligent woman I had ever met, and I cherished every word she uttered, and remembered almost every remark she made. It seemed to me no one could see art more understandingly, feel it more deeply or express themselves more clearly than she did." Both women shared a similar personality and an equal enthusiasm for art.

Friends and Patrons

During the many years of their long-lasting friendship Cassatt repeatedly advised Louisine on the purchase of art works, both of Old Masters as well as contemporary artists. In fact, Louisine Elder bought the first Impressionist work ever to enter an American collection, a pastel by Degas, on the advice of Cassatt. Their relationship deepened over the years, even after Louisine was married to sugar magnate Harry Havemeyer. During a collecting trip to Italy and Spain in 1901 the couple was accompanied by Cassatt, who helped them to find works by masters such as Veronese, Andrea del Sarto, and El Greco, among others. But the main achievement of the Havemeyers was that they were instrumental in bringing a large number of works of Impressionist art to the United States, and their rich collection was later donated to various public museums, among them The Metropolitan Museum of Art in New York.

During her visit to the United States in 1898–1899, Cassatt stayed with the Havemeyers and renewed the

Clarissa with a Fan (Turned Right with Her Hand to Her Ear)

1893, pastel on paper; 26 x 20 in. (66 x 51 cm).
Private collection, the United States.

Resting on a sofa in a thoughtful pose, Clarissa, a favorite model of Cassatt's during those years, is holding an open fan in her left hand; her head is turned slightly sideways. Her broad, round face, strong neck, and large shoulders reveal a forceful personality. This contemplative mood is reminiscent of Cassatt's earlier depictions of women in theaters. Except for the exposed parts of her body, the figure is only generally defined by broad strokes of pastels. The vivid and contrasting color scheme is clearly derived from Degas' works in this medium.

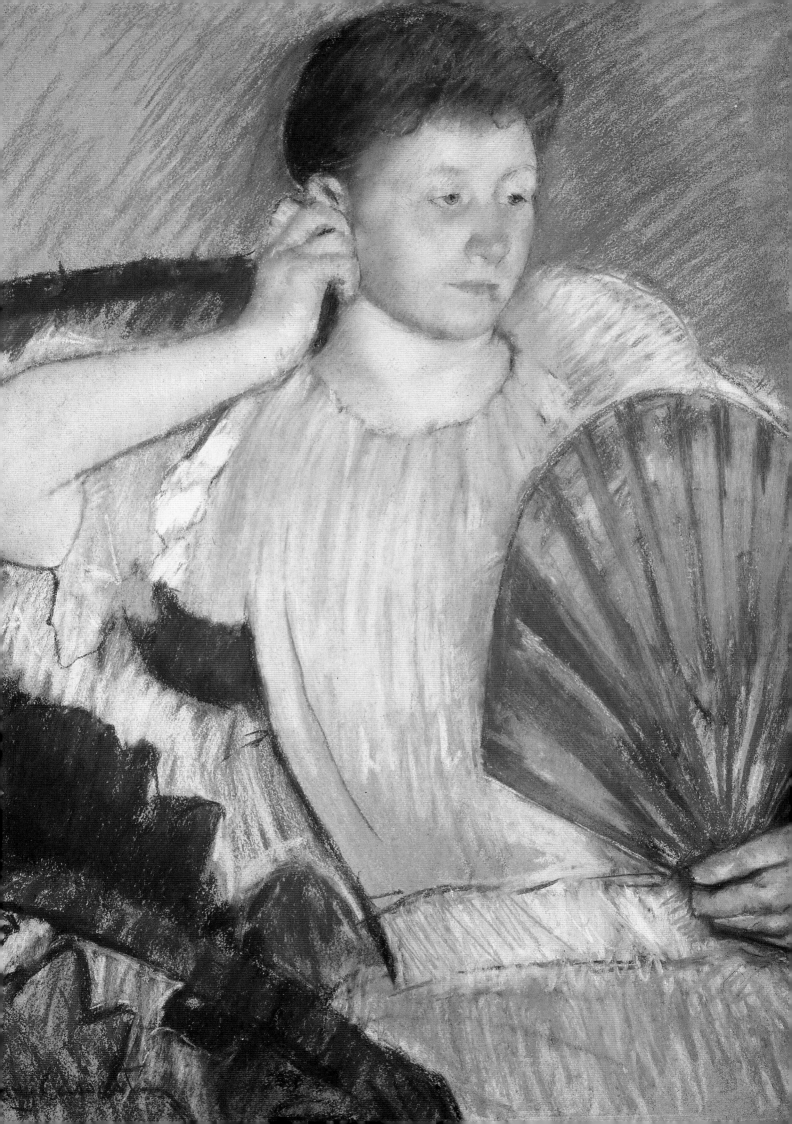

Girl Arranging Her Hair

1886, oil on canvas; 29 1/2 x 24 1/2 in. (74.9 x 62.2 cm). Chester Dale Collection, National Gallery of Art, Washington, D.C.
The girl's ungainly gesture of tying up her hair during the morning toilette reflects her unawareness of an intrusive observer. Her elbows are lined up in a diagonal thrust interrupted by the S-shaped coil of her dark hair. With parted lips that reveal a row of white teeth, she turns her head away, her glance apparently fixed on an invisible mirror. The palette is restricted primarily to white, lavender, and shades of rose and brown. When this work was exhibited at the eighth and last Impressionist exhibition in 1886, Degas expressed his admiration, exclaiming: "What drawing, what style!" He exchanged one of his own pastels for this picture, and the work remained in his possession until his death in 1917.

close ties with her friends. She also executed a number of portraits requested by her American collectors in New York, Boston, and Connecticut. Perhaps because these works were specifically commissioned, Cassatt's renderings of the sitters were more realistic and less Impressionistic. But her style had also changed. Cassatt had left Impressionism behind her, never following any of the succeeding avant-garde styles in Paris, such as Neo-Impressionism, with its pointillist brushwork, or Symbolism, with its broad color-field technique. Her style had become a personal one.

The Printmaker

Cassatt's achievements in the field of printmaking were important and immediately recognized by her artist friends. Although she came to this field with a certain prejudice, she ended up becoming deeply involved. At the beginning of her career she had considered prints to be inferior to oil paintings, and even among those, she had held figure paintings in higher esteem than landscapes or still lifes. This rather old-fashioned academic distinction was finally overcome when she discovered the importance that the print medium had gained over the last decades of the century.

The American artist James Abbott McNeill Whistler, well known to Cassatt, played an important role in the so-called etching revival in the second half of the nineteenth century. But the creative freedom and painterly methods of printmaking adopted by her colleagues (Degas and Pissarro) also convinced Cassatt of the advantages of producing prints in the same vein as paintings. Applying the procedures of the painter-printmakers allowed her to create works that could be sold at a lower price while still maintaining high quality and a sense of originality, an important aspect among both artists and collectors.

Since her days in Parma in 1872, where she had studied traditional engraving techniques with Carlo Raimondi, Cassatt had only occasionally produced engravings, some in drypoint technique, which requires a sure hand and accomplished drawing technique, and others in aquatint with its painterly quality. Most of these were done in 1879 in connection with *Le jour et la Nuit*, and all were done with black ink, which allowed only for a tonal range of the gray scale.

Portrait of Charles Dikran Kelekian at Age 12

1910, pastel on paper; 36 1/2 x 22 1/8 in. (92.7 x 56.2 cm).
Bequest of Beatrice A. Kelekian in memory of Mr. and Mrs.
Charles D. Kelekian, Walters Art Gallery, Baltimore.

The son of an American dealer friend from Paris who traded in Middle Eastern art is depicted in a more traditional portrait style. His soft, smoothly modeled face under a black hat contrasts with the pronounced vertical lines of the jacket and tie which seem to stress the boy's slender physique. Rarely did Cassatt allow her sitters to look straight out to the viewer. Here, however, the intense gaze of the boy's dark eyes is the most captivating feature of this work.

The Japanese Exhibition

In April and May of 1890, a large exhibition of Japanese prints borrowed from French collections was held at the École des Beaux-Arts in Paris. Cassatt visited the show several times, often in the company of other artists such as Degas and Berthe Morisot. In a letter to Morisot, Cassatt urged her not to miss the occasion: "You could come and dine here with us and afterwards we could go to see the Japanese prints at the Beaux-Arts. Seriously, you must not miss that. You who want to make color prints you couldn't dream of anything more beautiful. I dream of it and don't think of anything else but color on copper."

Although Japanese prints had been circulating at least since the 1870s, the display of over one thousand woodblock prints and illustrated books was a major stimulation for the painter-printmakers. Cassatt bought several prints at the exhibition, namely works by Utamaro (1753–1806) and Harunobu (1720?–1770). These artists belonged to the ukiyo-e movement of Japanese genre painting which developed in Japan during the seventeenth century. The word "ukiyo-e" is usually translated as "pictures of the floating world," referring to the depictions of everyday life such as domestic scenes, theater, sports, and others. These compositions were simple, brightly colored, and had a highly decorative effect that charmed many western artists including Degas, Monet, and van Gogh.

One of Cassatt's earliest experimental color prints, *A Portrait of the Artist's Mother* (c. 1889–1890), was based on an oil painting which preceded it (*Mrs. Robert S. Cassatt, the Artist's Mother*). The linear outlines of the composition have been softened through the etching process, and the light background has an atmospheric quality that is similar to the tonal range of the painting. Some of the details have been simplified for practical reasons; and because of the printing process the composition is reversed. It appears that the artist never exhibited this print in public and that she released it only much later in her life.

Soon after the Japanese exhibition closed Cassatt began to work on a set of ten color prints which were among her most original works, and an important contribution to the print medium. Her idea to create an entire set of prints was based on the Japanese tradition

A Portrait of the Artist's Mother

c. 1889–1890, soft-ground etching and aquatint;
9 15/16 x 7 1/16 in. (25.2 x 17.9 cm), platemark.
Rosenwald Collection, National Gallery of Art, Washington, D.C.
Based on the portrait of the artist's mother in San Francisco and executed shortly after the completion of the painting, this print shows the same composition in reverse. The black dress of the widow contrasts with the pale shawl worn over her shoulders and the light brown background, while the yellow and green touches of the flowers were added for greater variety. Only two impressions in color are known today. Although her work was often of a very personal subject matter, Cassatt always considered it to be for the art market and did not hesitate to sell when the occasion arose.

Mrs. Robert S. Cassatt, The Artist's Mother (Katherine Kelso Johnston Cassatt)

c. 1889, oil on canvas; 38 x 27 in. (96.5 x 68.6 cm).
The Fine Arts Museum of San Francisco, San Francisco.
Painted about six years after *Reading "Le Figaro,"* this portrait shows the artist's mother at nearly seventy-three, in a pose of resignation and contemplation. Mrs. Cassatt had been suffering from declining health. Her eyes are gazing into space; one hand supports her head, the other clasps a balled-up handkerchief. Her face and hands are carefully modeled with short brushstrokes, while the rest of the picture has been treated in a broadly painted fashion, leaving some areas unfinished with the white canvas showing. This sketchy quality gives the work its sense of freshness and spontaneity.

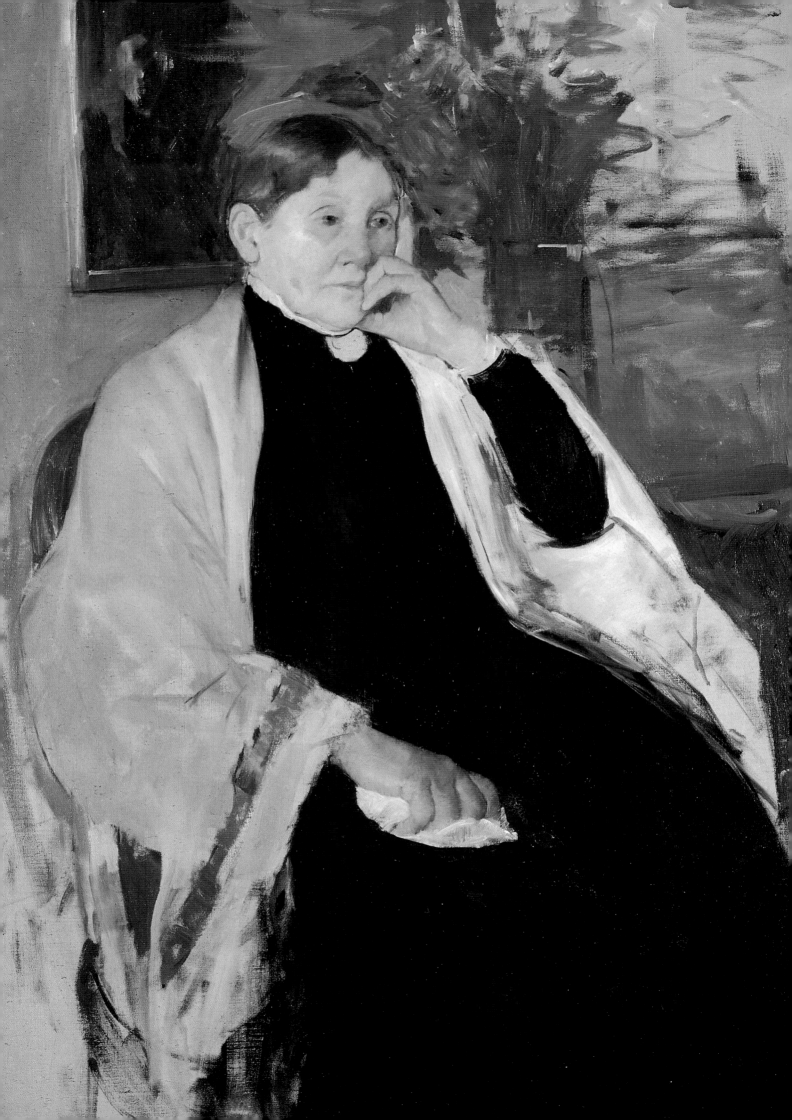

of a portfolio. Other artists had already adopted this serial approach and Cassatt's dealer, Durand-Ruel, also responded positively to the idea, claiming that it was preferable to sell an entire set rather than individual prints as this procedure guaranteed the even sale of all of the prints.

Assimilating the Japanese Style

How Cassatt assimilated the Japanese style can be seen in the first print of the set, *The Bath*, where a mother is about to bathe her infant. She combined the Japanese preference for simplicity in design, flat spatial arrangements, and bright local colors; even the figures exhibit some asian facial features. During the initial exploratory phase of this project Cassatt also experimented with various techniques and procedures, as is documented by the many different states (alterations of the plates) of *The Bath*: it exists in seventeen different versions, varying from each other in coloring and background treatment.

The time-consuming process of hand-inking each plate separately with every new printing shows that the artist paid as much attention to her prints as to her paintings and pastels. Hand-coloring each print separately rendered each one of them unique and therefore even more desirable to collectors. It is thought that about twenty-five prints of each plate in this set were pulled for the final edition. For this Cassatt had secured the help of the printer Leroy, who assisted her in the complicated advanced states which required up to three different plates for a single composition. Integrating different printing and etching techniques (drypoint, soft-ground etching, and aquatint), Cassatt attempted to achieve painterly effects. That Cassatt did not consider printmaking merely as a means of reproducing her own paintings or pastels in a cheaper medium is also attested to by the fact that she executed engravings which were later used as models for her paintings.

The Galerie Durand-Ruel

The results of these efforts were shown in Cassatt's first one-woman exhibition in April of 1891 at the Galerie

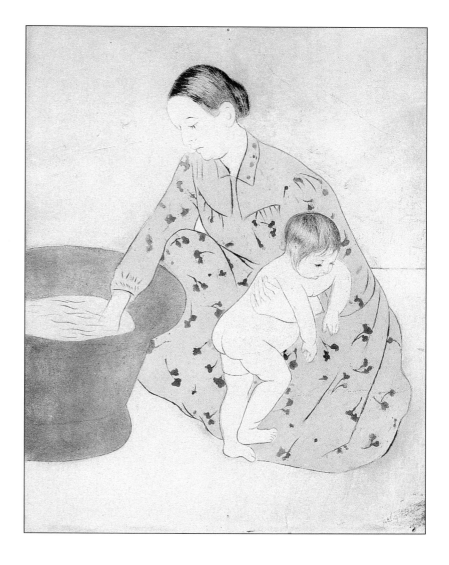

In the Omnibus

1890–1891, drypoint and aquatint; 14 3/8 x 10 1/2 in. (38.4 x 26.7 cm), platemark. Rosenwald Collection, National Gallery of Art, Washington, D.C.
The subject of this print is unique in the entire oeuvre of Cassatt in that it shows a scene of urban life in Paris. In a later development of this print she included a landscape with a bridge crossing the river Seine seen through the windows, which are left blank in this version. Although a great admirer of Paris, the artist included a glimpse of a cityscape only in one other work, *Susan on a Balcony Holding a Dog.*

The Bath (The Child's Bath)

1890–1891, drypoint, soft-ground etching, and aquatint; 12 5/8 x 9 3/4 in. (32.1 x 24.7 cm), platemark. Rosenwald Collection, National Gallery of Art, Washington, D.C.
Cassatt's effort to individualize her prints may be documented with this work, of which at least seventeen different states are known. She colored each plate by hand, varying the tonal range before the printing. In this fashion she followed the characteristics of Japanese prints by artists praised among their contemporaries not only for their stylized beauty of line, but also for the uniqueness of each printed image, an aspect dear to many collectors.

The Banjo Lesson

c. 1893, drypoint and aquatint; 11 9/16 x 9 3/8 in.
(29.4 x 23.8 cm), platemark. Gift of Mrs. Jane C. Carey
as an addition to the Addie Burr Clark Memorial Collection,
National Gallery of Art, Washington, D.C.

The subject was repeated in a pastel (*The Banjo Lesson*) which was presumably made after the print. Here, the facial expressions are more stylized and less individual, thus contributing to a more distanced and typified representation of the group. Cassatt's interest in depicting women in the role of self-sufficient, educated people reverberates throughout her oeuvre as a reflection of her own independent life and of her interest in the women's causes, (namely, the suffrage movement in the United States).

Durand-Ruel, where at the same time the Société des peintres-graveurs (Society of Painter-Printmakers) displayed their works. New rules set up by the members of this group reserved the participation in their exhibition for French artists only. As an American, Cassatt was henceforth excluded, as was Camille Pissarro, a native of the Danish West Indies. To compromise, Durand-Ruel offered to show their works at the same time as the group exhibition—in two separate adjacent rooms, a position that actually guaranteed them the special attention of critics and visitors.

In a letter to his son Lucien, Pissarro described Mary Cassatt's prints with enthusiastic words: "The tone even, subtle, delicate, without stains on seams; adorable blues, fresh rose, etc. . . . the result is admirable, as beautiful as Japanese work, and it's done with printer's ink!" Cassatt used commercial printer's ink and mixed the colors herself to achieve the desired hues. She also worked with the best-quality copper plates and tools as well as a good printer, thus ensuring the exceptional results of her endeavor.

The subject matter of *In the Omnibus*—two women with a child riding in this modern vehicle of public transportation—is unique in Cassatt's oeuvre; nowhere else can one find a similar scene of everyday life in the public realm. Later states of this print (there are seven in total) include a bridge over the Seine in the background. In this third state the flatness of the space and the simple linear outlines are still closer to the Japanese spirit than the later versions.

The last print in this set of ten may well have been *The Letter*, judging from the confidence with which

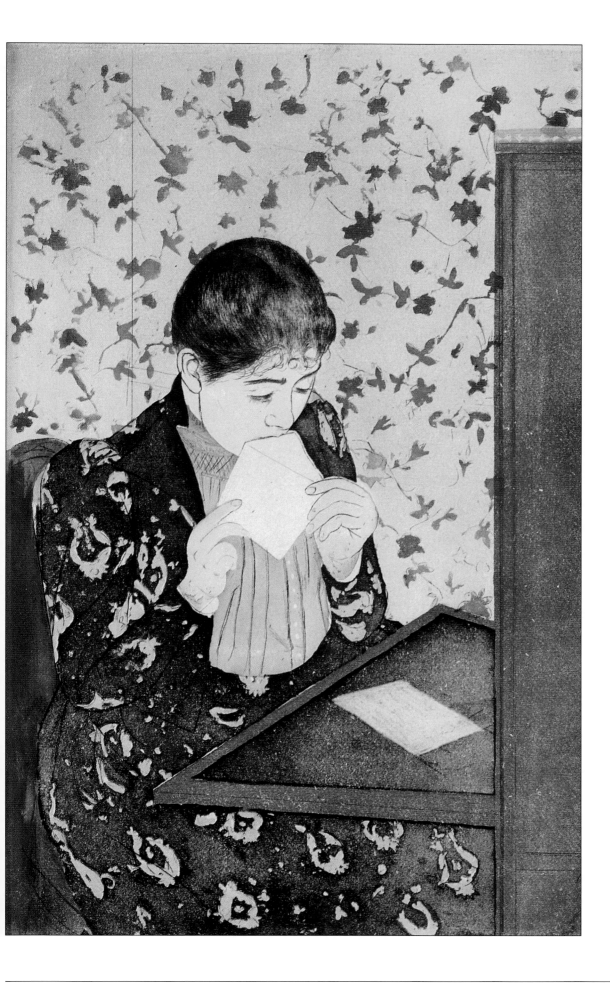

The Letter

1890–1891, drypoint and aquatint; 13 5/8 x 8 5/16 in. (34.5 x 21.1 cm), platemark. Bequest of Guy M. Drummond, Montreal, 1987, National Gallery of Canada, Ottawa.
After working doggedly for nine months in the country on the project, Cassatt finished a set of ten prints which she intended to show at the painter-printmaker's exhibition in the spring of 1891. Although eventually excluded from the show for being a foreign national, she was able to exhibit her work simultaneously in a room of her own at the gallery of Durand-Ruel, who also hosted the annual event. The most popular of all the color prints, *The Letter*, might have been the last one in the series, judging from the accomplished technique and the fact that only four states are known.

Cassatt created the composition and used the medium. It is also the most popular work in this series. A woman sitting at a writing desk is about to seal the envelope of a letter by licking its edges. Women writing letters have been long established as a subject in Western art, but this casual gesture, so familiar to every viewer, appears to be rather unique. Again, the decorative pattern of the woman's dress and the floral motif of the wallpaper as well as her hairstyle clearly reflect Japanese examples. The remaining prints of this set include scenes of women in interiors, women at their toilette, and women with children.

Exploring the Medium

During the following years Cassatt produced a few more color prints which might have been intended for a new set. But the size, medium, and palette of these prints are dissimilar from one another and the works were eventually exhibited and sold separately. In *The Banjo Lesson* the artist used an additional technique called monotype, in which ink is applied to an unworked plate and then printed. This allowed for a greater variety and uniqueness of each print since the results could not be exactly repeated. The effect of the painterly brushstrokes on the woman's blue skirt was a calculated result of her working methods. Content with the outcome of *The Banjo Lesson*, Cassatt produced a total of forty prints, an unusually high number for her. Two related pastels with this subject were apparently made after the print and are proof of the composition's success.

It is likely that Cassatt executed *Feeding the Ducks* at her residence at Mesnil-Beaufresne during the summer of 1895. The previous year she had purchased this château which included a garden with a large pond. She had also moved her printing press there from her studio in Paris. As Louisine Havemeyer later recollect-

Feeding the Ducks

c. 1895, drypoint, soft-ground etching, and aquatint; 11 5/8 x 15 1/2 in. (29.5 x 39.3 cm), platemark. Daniel J. Terra Collection, Terra Museum of American Art, Chicago. Inspired by the pond in her garden at the Château de Beaufresne, Cassatt also used this motif in a related painting of about the same period, *Summertime*. Here, a child is with the two women, who are showing the infant how to feed the ducks approaching their boat. This is the fourth state of the print, of which other color variations exist. The more distant viewpoint and the inclusion of the surrounding space is characteristic of Cassatt's later style.

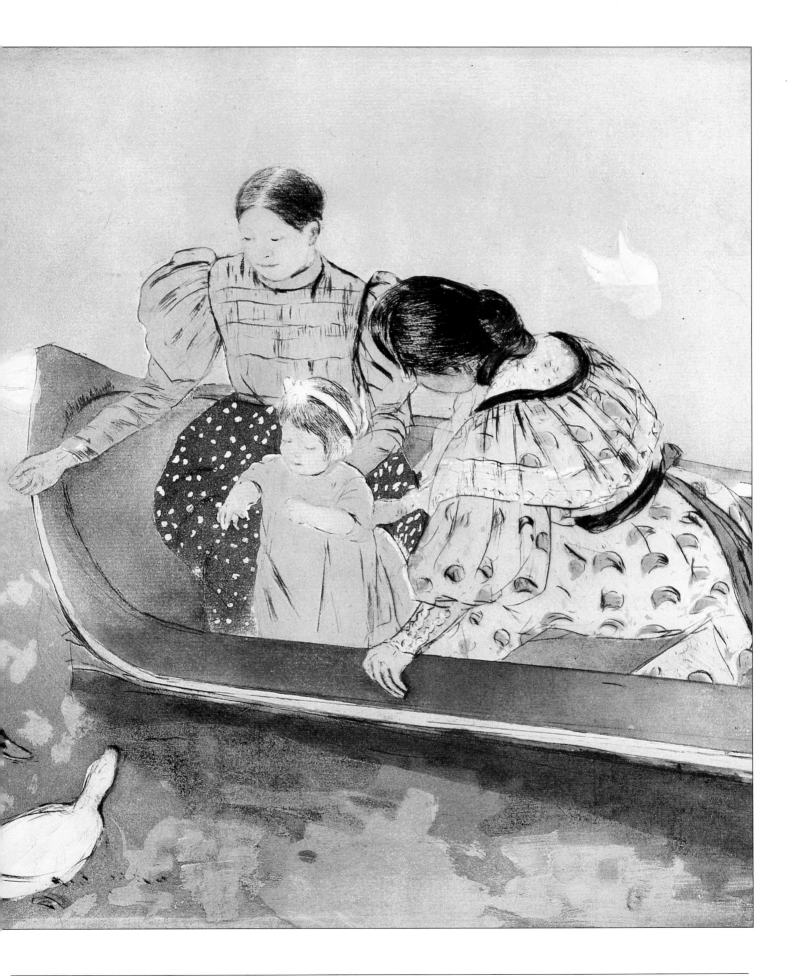

ed, Cassatt worked there "in her grey blouse in the small pavilion over the dam which fed her *pièce d'eau* and where she had installed her printing press. There she would work while daylight lasted with the aid of a printer; she did her own coloring and wiping of the plates. It was the cost of much physical strain for she actually did the manual work."

Based on two preceding oil paintings, *Feeding the Ducks* is an outdoor scene of a bucolic character. Two women with a child in a boat are feeding the ducks swimming on the water. The process of teaching the infant how to feed the birds and attract their attention has been reproduced with great intimacy. Cassatt was indeed a careful observer of the human psyche and capable of translating the results of her examination into her own artistic language. During the last period of her career she focused more and more on depictions of mothers and children, a theme on which her fame and popularity is largely based today.

Susan on a Balcony Holding a Dog

c. 1882, oil on canvas; 39 1/2 x 25 1/2 in. (100.3 x 67.7 cm). The Corcoran Gallery of Art, Washington, D.C.

The young model was a cousin of Mathilde Valet, Cassatt's housekeeper and maid. Her plain but strong features are reminiscent of Lydia. Her white dress is painted with subtle variations in tone caused by the changing light and surrounding colors, and the little dog on the girl's lap is one of Cassatt's pet Brussels griffons.

Children Playing on the Beach

1884, oil on canvas; 38 3/8 x 29 1/4 in. (97.4 x 74.2 cm). Alisa Mellon Bruce Collection, National Gallery of Art, Washington, D.C.

With the exception of individual portraits, children are rarely depicted alone in Cassatt's works. Here, seen from the perspective of an adult looking on from above, two children are busy playing in the sand on the beach. They appear quietly absorbed in the earnest pursuit of their activity. This is the artist's only beach scene, the inspiration for which she may have found during a short stay at the seashore in the summer of 1885, after developing a serious case of bronchitis. The painting was almost certainly executed in her studio after her return.

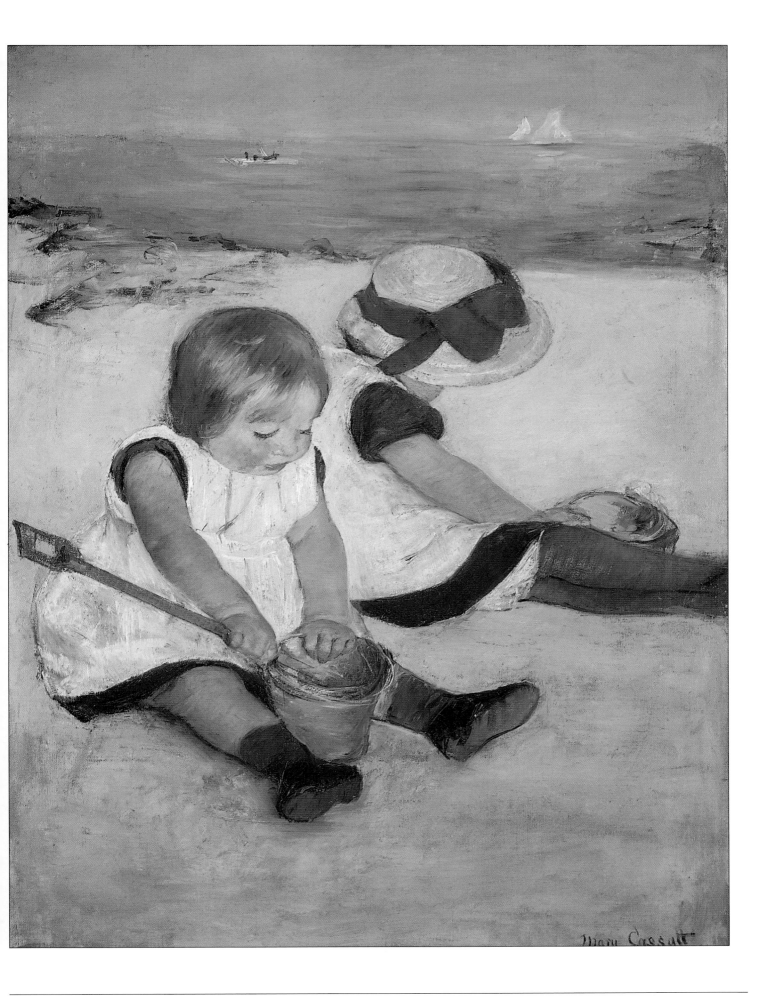

CHAPTER FOUR

A WOMAN'S WORLD

The role of the modern woman in contemporary society was an issue that concerned Mary Cassatt throughout her life. From her early childhood onward she demonstrated an independent-minded and strong-willed character; she fought for her convictions and challenged people around her. She ignored her father's concerns about his daughter becoming an artist and ultimately renounced marriage and motherhood for the sake of her career. During World War I, already seventy-one years old, she supported the American suffragettes' cause by lending works to a benefit exhibition organized by her friend Louisine Havemeyer. Believing that women could prevent another war by gaining the right to vote and by taking an active part in the government of their country, Cassatt wrote to her friend on May 30, 1914, "You know how I feel about the, to me, question of the day, and if such an exhibition is to take place I wish it to be for the cause of Woman Suffrage."

Earlier, when the case of Alfred Dreyfus rocked France in the late 1890s and split the country into two factions, Cassatt sided with the Dreyfusards, who believed in the innocence of the French officer accused of spying for the Germans. Degas joined the ranks of Dreyfus' anti-Semitic adversaries, but by that time Cassatt no longer maintained the same close friendship with him, which had been so crucial a source of inspiration for her. Increasingly blind and misanthropic, Degas became a recluse; he gave up painting around 1908.

Mother and Child Scenes

The two decades around the turn of the century proved to be a highly successful and productive period for Cassatt. She focused almost exclusively on depictions of mothers and children, a subject which became her signature theme. Early critics had already noticed that Cassatt herself was unmarried and without children. Although stung by such insidious remarks, Cassatt

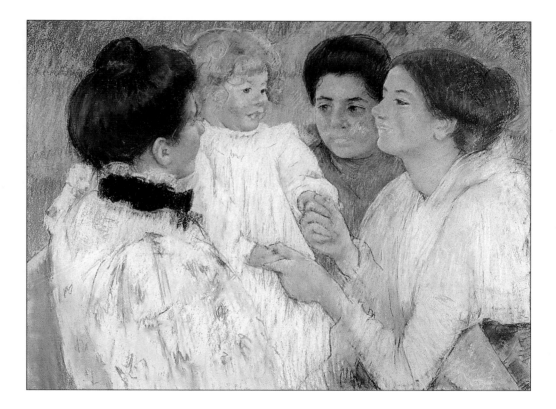

Hélène de Septeuil

detail; 1889–1890. Louise Crombie Beach Collection, The William Benton Museum of Art, University of Connecticut, Storrs, Connecticut.
The difference between the smoothly modeled faces where the pastel has been carefully rubbed in and the chalky texture of the more coarsely treated strokes on the surface of the clothes can easily be seen. The greenish tints on the woman's jaw and front have been used to indicate the shaded areas of her face. Such a refinement in the use of this medium was equaled only by the works of Edgar Degas.

Women Admiring a Child

1897, pastel on paper; 26 x 32 in. (66 x 81.2 cm). Gift of Edward Chandler Walker, Detroit Institute of Arts, Detroit, Michigan.
The little girl is the main focus of attention in this complex composition. Surrounded by three admiring women, each seen from a different angle, the child sets the playful tone of the scene by responding with a smile to the woman at the right, who has grasped her hands. Here, Cassatt's palette is lighter and her pastel technique more controlled than in previous years; soon her interest would shift increasingly to child portraiture.

did not waver in the pursuit of her work. It is not known what exactly motivated the artist in her choice of subject. Most likely the mother and child scenes were a natural outcome of her portraits of friends and family members, but they almost certainly reveal, too, a yearning for children. Cassatt believed that being a mother was a privilege and right of womanhood, and she was certainly aware that she had missed the opportunity to experience it herself. For years she had seen her nieces and nephews growing up around her. During her sister Lydia's illness she had experienced the pathos of nursing another person, and she felt this perhaps even more so when her aging parents began to depend on her. Surprisingly, Cassatt turned out to be an excellent nurse. Her father died in 1891, and her mother, to whom Cassatt had become very close after her father's death, passed away in 1895.

Realizing the possibilities which mother and child scenes offered, Cassatt continued to explore and develop this

The Child's Caress

c. 1890, oil on canvas; 26 x 21 in. (66.0 x 53.3 cm). Wilhelmina Tenney Memorial Collection, Honolulu Academy of Arts, Honolulu. In the mature phase of her career Cassatt moved away from Impressionistic renderings and pursued a more compact style characterized by solid forms with clear, linear definition. A good example is this painting, where the woman's sturdy figure is complemented by the pudgy little girl sitting across her lap. The brushstrokes are smooth and creamy, delicately modeling the forms. Light plays a major role in defining the bodies and the texture of the clothes rather than diffusing their substance.

theme regardless of demeaning criticism. Just like Degas, who had concentrated on images of jockeys, ballerinas, and bathers, or Monet with his serial paintings of landscapes and the Rouen cathedral, Cassatt considered her maternal scenes to be a fruitful artistic activity offering a large variety within narrowly defined boundaries. In a similar fashion earlier in her Impressionist years, she had pursued the subject of women reading or in a theater. It should be noted though that the theme of women and children was popular among many artists in Paris around 1890, including van Gogh, Gauguin, and the

Symbolist painters Pierre Puvis de Chavannes and Eugène Carrière.

At the same time as Cassatt developed her mother and child pictures her Impressionistic style changed, taking on a more linear quality such as in her prints. This understanding that lines were an essential part of a composition was shared not only by Degas, but also by van Gogh and Gauguin. The concept of "synthetism," which favored the reduction of lines to the necessary, became the basic principle of her new works. They were now invested with deeper psychological and emotional feelings expressed by abstract lines. Probably for this reason Cassatt worked almost exclusively in pastel, which is closer to drawing, a technique intended to weave many smaller lines together.

Hélène de Septeuil

One of the first works from this period was *Hélène de Septeuil*, a pastel of 1889–1890. A woman in a plain black gown is holding in her arms an infant dressed in a checkered skirt and wearing a yellow hat. The forms are defined with clear outlines and energetic strokes of the pastel stick. Only the flesh and hair are softly modeled and have taken on a velvety quality. This playful distinction of different textures was one of Cassatt's great achievements in this medium. The intimacy and tenderness between the woman and the child belies the fact that the sitters were actually not related to one another. The little girl, named Hélène, was from the village of Septeuil where the Cassatt family spent the summer of 1889, while the woman was one of the artist's models. In fact, almost all of Cassatt's mother and child scenes do not depict actual mothers with their own children, since the artist preferred to select her models and match the appropriate physical types in order to achieve the desired results.

The Caresses

In *The Child's Caress*, an oil painting of about the same period, the sturdy figure of the dark-haired woman is coupled with a blond-haired, chubby little girl who is sitting on her lap. In a playful, touching gesture the child is making physical contact with its mother by putting its hand on her mouth. The

Hélène de Septeuil
1889–1890, pastel on paper; 25 7/8 x 16 1/2 in. (63.5 x 40.6 cm). Louise Crombie Beach Collection, The William Benton Museum of Art, University of Connecticut, Storrs, Connecticut.
Many of Cassatt's mother and child scenes are based on models carefully chosen by Cassatt for the special effects she tried to achieve. In fact, the two were rarely actually mother and child. The little girl here, Hélène, was from the village of Septeuil, where the artist's family spent the summer of 1889. Her name can be determined by an inscription in a related engraving, while the "mother's" identity remains elusive. This highly accomplished pastel was shown in 1891 at Cassatt's first solo exhibition at the Durand-Ruel gallery in Paris.

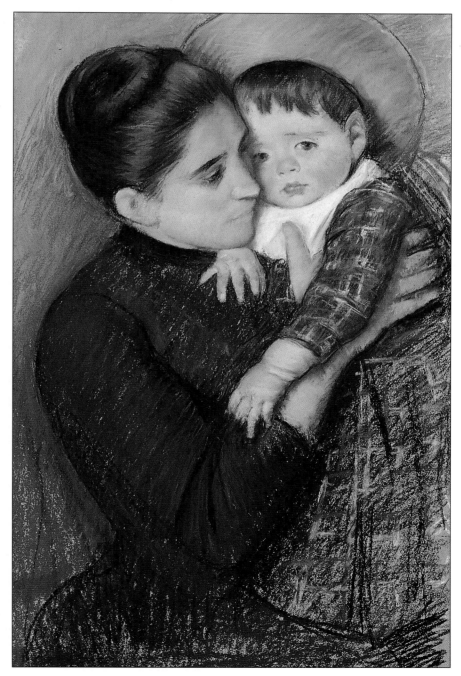

The Bath

c. 1893, oil on canvas; 39 1/2 x 26 in. (100.3 x 66 cm).
Robert A. Waller Fund, The Art Institute of Chicago, Chicago.
This monumental painting of the mother and child theme is
one of Cassatt's most successful works and was immediately
shown at her large solo exhibition at Durand-Ruel's gallery
in 1893. Looking down from a bird's-eye perspective, the
figures appear in their full length. The viewer is also offered
a more complete glimpse of the surroundings, which include
an Oriental rug and a chest of drawers decorated with painted
flowers. A solemn grandeur emanates from this group, which
does not allow the viewer to penetrate the intimacy of the action.

forms of their bodies are clearly delineated against the
darker background of garden plants. The skin and
clothes are painted with smooth brushstrokes, achieving
the effect of a certain slickness that differs markedly
from the flickering surface of Cassatt's Impressionist
paintings. The models for *The Child's Caress* are the same
as in the related print, *The Bath*.

Baby's First Caress is also related to a print from the
same series. Again, the child is reaching out for its moth-
er's face, a gesture to which the woman reacts by holding
the baby's left foot with her left hand. She is seated in a
three-quarter pose, turning her face slightly away from
the viewer toward the child. As in various other maternal
paintings the infant is nude. The smoothly
rendered skin of the child shows reflections
of the green and orange tones of the pattern
on his mother's gown. The background
repeats the same hues, thus creating a har-
monious, unified space.

Another reason for the appeal of this
theme leads back to Cassatt's early interest
in Italian and Spanish Old Master works,
such as Correggio's and Parmigianino's
Madonna and child paintings. Cassatt had
studied intensely the subjects and tech-
niques of the past and translated her expe-
rience into her own artistic language.
Although immersed in the observation of
contemporary life as required by
Impressionism, Cassatt was always keenly
aware of the echoes of the past and regular-
ly visited museums, mainly the Louvre.
This notion is backed by a comment made
by Cassatt's dealer, Paul Durand-Ruel, who
called her the painter of *la sainte famille
moderne* (the modern Holy Family). And
Louisine and Harry Havemeyer referred to
one of the mother and child paintings they
owned as Cassatt's "Florentine Madonna."
Cassatt's works indeed express a calm
grandeur and solemn grace that imbues
them with a seemingly religious feeling.

The almost serial treatment of the mater-
nal subject with its various spin-offs was
also the result of the growing popularity of
her works at the end of the century. A
review of her paintings exhibited at the
Impressionist show at Durand-Ruel's
gallery in New York in February of 1899
praised her mother and child compositions
in particular: "The conventional woman,
elegant, sickly, and insipid, and the conven-
tional infant are nowise to Miss Cassatt's

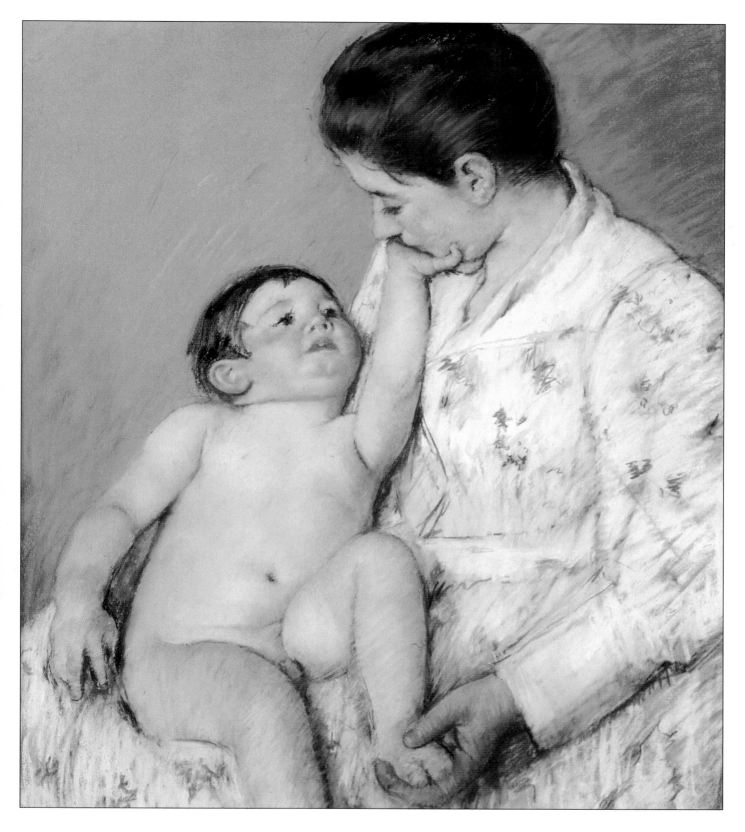

Baby's First Caress

c. 1890, pastel on paper; 30 x 24 in. (76.2 x 61 cm). Harriet Russel Stanley Fund, New Britain Museum of American Art, New Britain, Connecticut.
A number of interlocking gestures define the intimate relationship between this mother and child. The baby touches the woman's face, while she, in turn, holds his foot directly below. These movements are linked by the straight line formed by the child's arm and lower leg, which divides the entire composition in half. The outer arms of the two figures enclose the center of the picture, while direct glances further enhance the bond between the two figures. The short, dense strokes of warm, rosy flesh tones give weight to the child's body compared to the more broadly defined, cooler coloring of the woman's dress and the plain background.

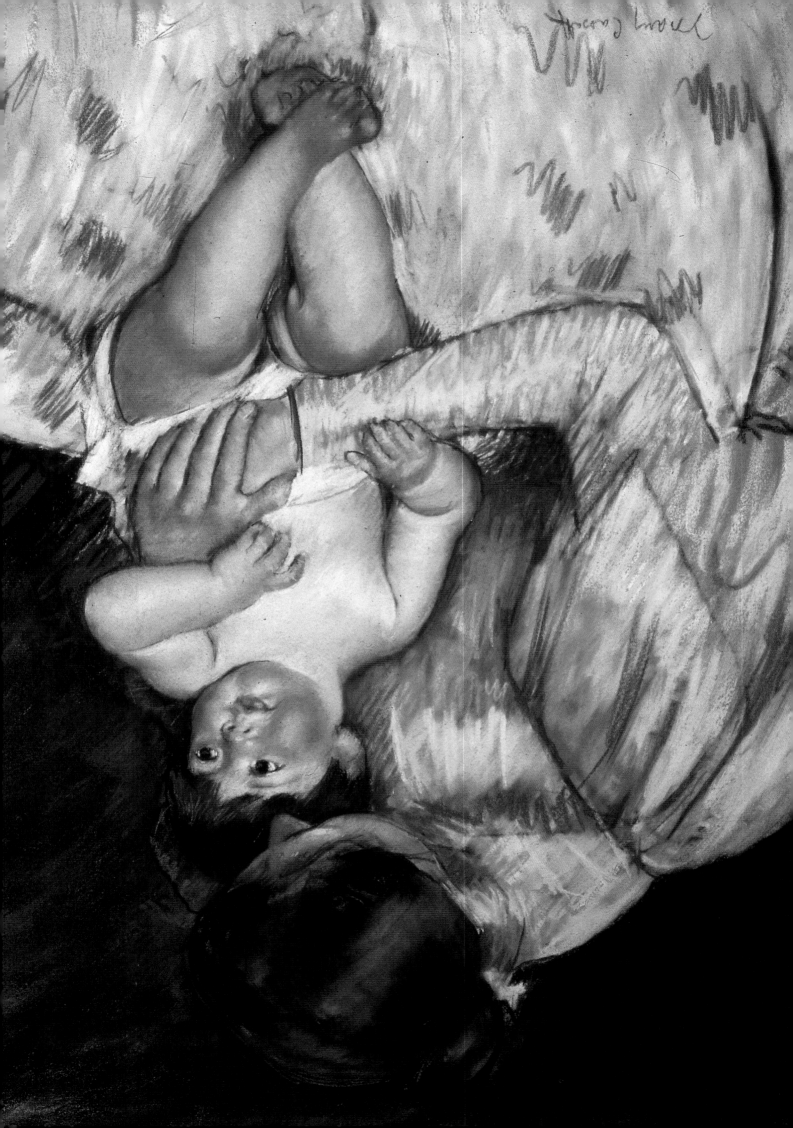

taste. She likes them strong, lusty, brown or rosy, alive and glad of it." This interpretation not only underlines Cassatt's understanding of womanhood, but also her quasi-religious veneration of the relationship between a mother and her child.

The Mural

In early 1892, Mrs. Potter Palmer, a prominent collector from Chicago and president of the Board of Lady Managers for the Woman's Building of the World's Columbian Exhibition to be held in Chicago in 1893, visited Cassatt in Paris, offering her a commission to execute a mural for the building, which was being designed and decorated by various prominent American women artists. It was intended to display the products of female skill and craftsmanship. Cassatt was commissioned to execute the mural for one of the two large tympana facing each other at the end of the Hall of Honor in 12- by 58-foot spaces. The other one was painted independently by the American artist Mary Fairchild Mac-Monnies, who—though also living in France—was better known in America than Cassatt.

The subject matter for the two murals was the theme of the development of women from "Primitive Woman" (Mary Fairchild Mac-Monnies) to

Mother and Child

1893, pastel; 31 7/8 x 25 1/2 in. (81 x 65 cm). Pushkin Museum, Moscow.
Sitting with crossed legs on his mother's lap, the infant has turned his head slightly away, directing his eyes towards an invisible person or object outside of the painting. The mother's face is almost invisible, bending down toward the child and thus underscoring the prominence of the young sitter. Cassatt animated the summarily drawn surface with vigorous strokes of red, green, and blue pastel, while carefully modeling the child's skin with hues of pink.

Sleepy Baby

c. 1910, pastel on paper; 25 1/2 x 20 1/2 in. (64.7 x 52 cm). Munger Fund, Dallas Museum of Art, Dallas.
Short, nervous strokes of pastel define the bodies of the mother with her sleeping baby while the flat background is rendered with regular, parallel hatching. The figures are arranged in the form of a pyramid with intersecting movements of arms and hands. Cassatt's choice of contrasting pink and blue hues is somewhat unusual. Her first biographer, Achille Ségard, who interviewed the artist in 1912, remarked that Cassatt's idea of love between mother and baby is found to be "in intimate accord with the elegance of her lines, the arabesques which part and are rejoined, the delicate tonalities and the caress of her brush."

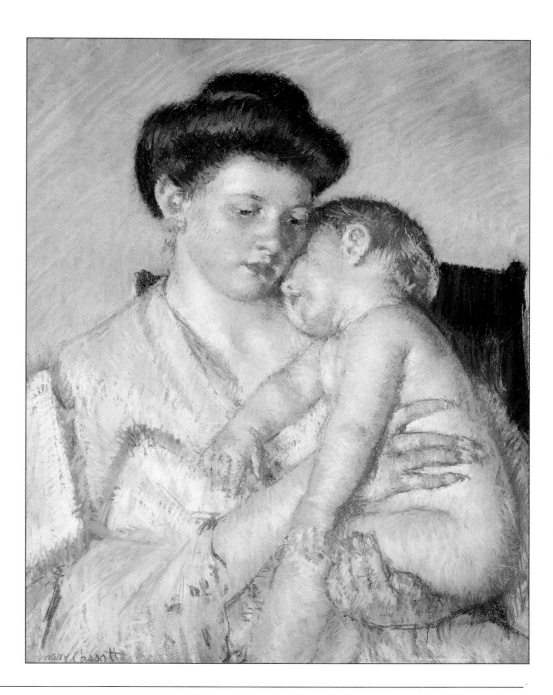

"Modern Woman" (Cassatt). Today, both works are known only through contemporary photographs, since they appear to have been destroyed along with the buildings after the closing of the exhibition. Although an important work and Cassatt's first major recognition in her native country, the mural—as can be judged from related paintings and drawings as well as photographs—was not her most successful work. Indeed, the artist herself had many doubts during its long and laborious execution. Cassatt had little experience with public art, and the size alone of the large space was in itself daunting. After she had discussed the project with Degas, she decided to grasp this unique opportunity: "The bare idea of such a thing put Degas in a rage and he did not spare every criticism he could think of, I got my spirit up and said I would not give up the idea for anything." Once again it was her own stubbornness in the face of opposition which spurred her energy. It should be noted that Cassatt was Mrs. Potter Palmer's second choice; her old rival Elizabeth Gardner had been the first. Gardner, whose style was quite academic and of polished perfection (she eventually married the painter William Bouguereau, a leading artist of the École des Beaux-Arts), had declined the invitation, citing her advanced age as a hindrance.

At the center of Cassatt's composition was a group of "Young Women Plucking the Fruits of Knowledge or Science" from a tree. Cassatt was a strong supporter of education for women, and she had advised her family on the Parisian schools which her nieces and nephews attended during their prolonged stays. The two panels to the left and right showed "Young Girls Pursuing Fame" and women representing "Arts, Music, Dancing." Achieving fame was one of Cassatt's own personal goals, while the arts in general were a field in which she felt modern women could excel.

Breakfast in Bed

1897, oil on canvas; 25 5/8 x 29 in. (65.1 x 73.6 cm).
Virginia Steel Scott Collection, The Henry E. Huntington
Library and Art Gallery, San Marino, California.

One of the most tender and intimate renderings of the theme of maternal love, this painting contains all the characteristics of Cassatt's mature style: loosely applied paint, broken contour lines, and a more painterly approach that breaks away from tightly modeled and compartmentalized forms. The perceptive, distraught child is enveloped in the arms of his sleepy mother. The curvilinear forms of the cup, saucer, and tray in the still life to the right repeat the shapes of the two heads. Squares of apple-green areas in three corners frame and stabilize the dominating scheme of white and rosy flesh tones. Blue highlights on the sheets and pillows activate the broadly brushed surface.

The Boating Party

1894, oil on canvas; 35 7/16 x 46 1/8 in. (90.2 x 117.2 cm).
Chester Dale Collection, National Gallery of Art, Washington, D.C.
Most likely inspired by Edouard Manet's *Boating*, Cassatt
began this painting during a vacation at Antibes on the
Riviera in early 1893. It is one of her largest and most ambit-
ious works. The child, held on the woman's lap, is clearly
the center of the composition. The angle formed by the
man's straight arm and the oar points directly at the baby,
as do the curves of the boat's sides and the tip of the sail.
By severely cropping the boat at the bottom and right side,
Cassatt gives the viewer the sensation of being another
passenger. Vivid colors and the suppression of shadows
create the illusion of a summer day bathed in bright sunlight.

Cassatt never intended to travel to Chicago for the exhi-
bition, where the mural was installed high up under the
ceiling of the hall. There she would have noticed that she
had miscalculated the proportions of the figures and the
effects of her strong palette on the surrounding space. The
overall response to the mural was cool. Nevertheless,
Cassatt was ultimately pleased with the experience and was
full of renewed energy to continue her regular work.

The Post-Mural Period

After the initial success and critical praise for her moth-
er and child scenes, Cassatt's works became more elaborate
and less direct. In *The Bath* she renewed the theme previ-
ously explored in a print, but now enlarged the space by
choosing a higher viewpoint, thus achieving grandeur and
psychological distance. Details like the stripes on the

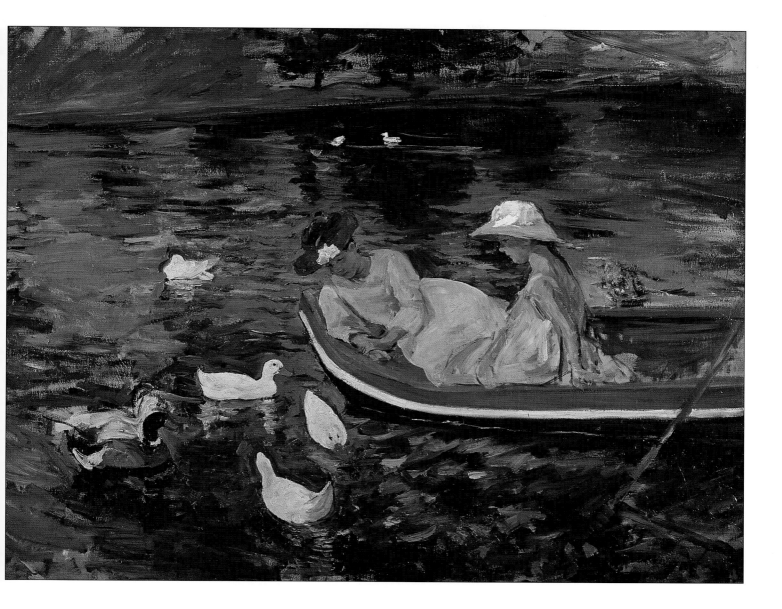

mother's robe and the squares of the Oriental carpet assume a more decorative function and are intelligently played off against each other.

By now Cassatt's figures had become increasingly solemn and self-conscious while losing their previous playfulness and ease. In *The Boating Party*, the idea for which came to Cassatt during a stay at Antibes in 1894, the mother and child theme has been expanded into a more comprehensive outdoor genre scene. The strictly balanced elements of the composition emphasize Cassatt's concern for a classical equilibrium. The large size of the painting and the inclusion of a male figure in the composition are indicative of her new, expansive, post-mural style.

In 1893, a second one-woman show at Durand-Ruel's gallery consolidated her position as a leading woman artist of her time. Two years later, in April, 1895, she had

Summertime

c. 1894, oil on canvas; 29 x 38 in. (73.7 x 96.5 cm).
The Armand Hammer Collection, UCLA at the Armand
Hammer Museum of Art and Cultural Center, Los Angeles.
There are several versions of this subject, which must have fascinated the artist over some time. Probably painted during the summer at the Château de Beaufresne near Paris, it may represent the large pond behind the house. Compared to the solid and tightly composed *Boating Party*, the broadly applied paint gives this work the immediacy and freshness of a rapidly executed sketch. The cooling effect of the water enjoyed during the heat of a summer afternoon has been perfectly captured by the extensive use of blue and green. The high horizon and the asymmetrical arrangement of the composition, in which the boat is cut by the frame, shows Cassatt's renewed interest in Japanese woodcuts.

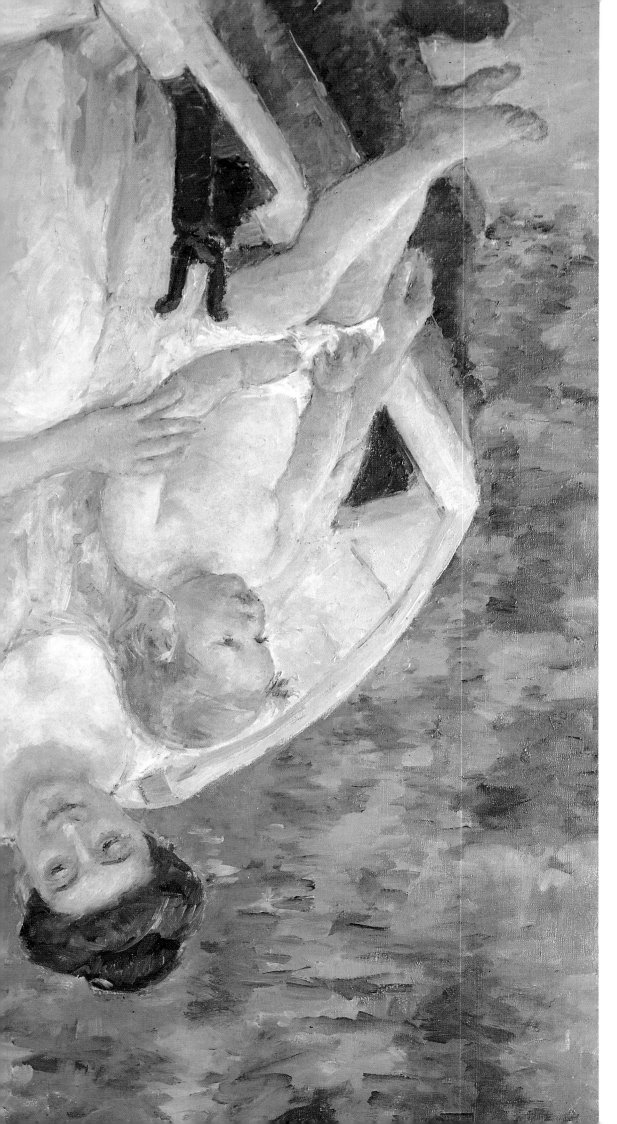

The Bath

1910, oil on canvas;
38 7/8 x 50 3/4 in.
(99 x 129 cm).
Musée du Petit Palais,
Paris.

Related to works like
Feeding the Ducks
and *Summertime*, this
painting also most
likely shows the pond
behind the artist's
mansion at Beaufresne.
The boat, cut off by
the frame at the bot-
tom, runs with a diag-
onal thrust across the
surface. Looking down
from a high vantage
point, the viewer
witnesses a tender
exchange of glances
between the two
women and their chil-
dren. The pale tones
of their skin are set
off against their con-
trasting yellow and
purple dresses and the
dark blue and green
water. A sensation of
stillness and peace per-
vades this rendering
of a fleeting moment.

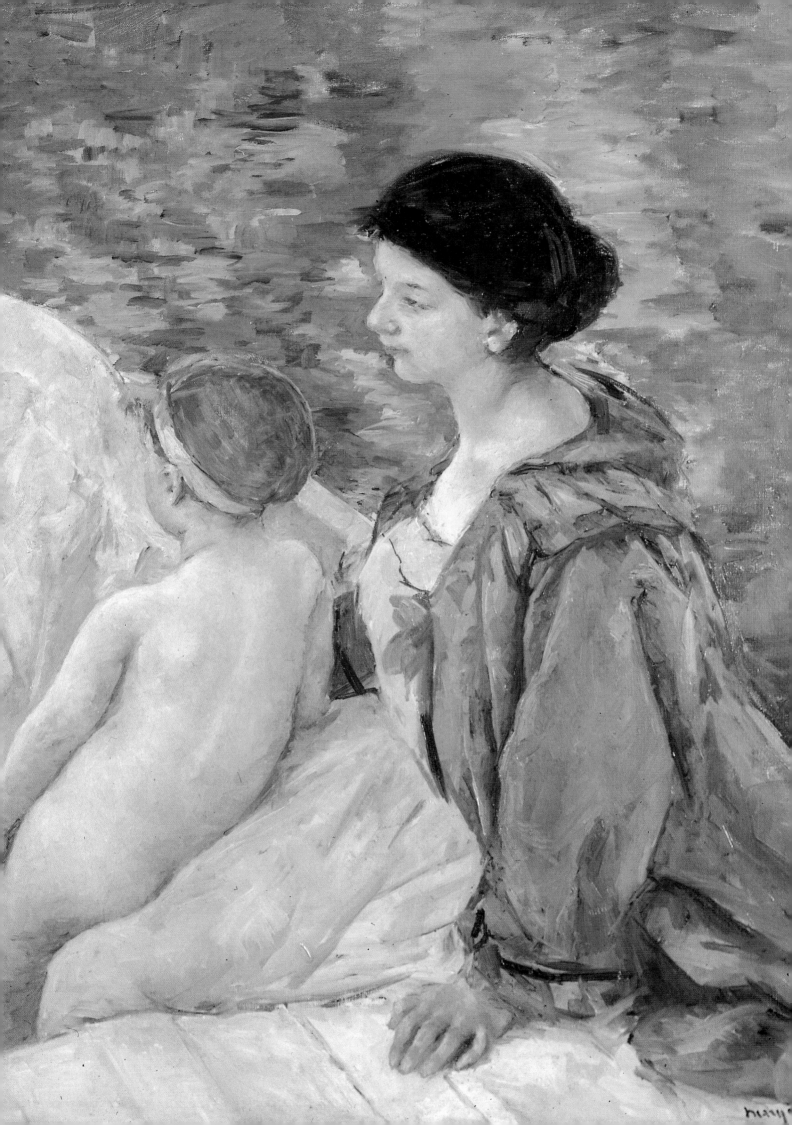

**Nurse Reading to
a Little Girl**

*1895, pastel on paper, 23 3/4 x
28 7/8 in. (60.3 x 73.3 cm).
Gift of Mrs. Hope Williams
Read, 1962, The Metropolitan
Museum of Art, New York.*

In her mature period Cassatt
revised the tight scheme of her
earlier mother and child com-
positions to allow for a livelier
and more playful depiction of
her subjects. She also studied
the pastel techniques of the
Old Masters again, namely
Maurice Quentin de La Tour
(1704–1788). Here, a nurse
is reading to a little girl in a
garden, probably at Cassatt's
recently acquired Château
de Beaufresne at Mesnil-
Théribus, about 50 miles
(80 kilometers) north of Paris.

**Mother Playing
with Her Child**

*c. 1897, pastel on paper, 25 1/2 x 31
1/2 in. (64.8 x 80.0 cm). Gift of
Dr. Ernest Stillman, 1922, from
the Collection of James Stillman, The
Metropolitan Museum of Art, New York.*

The curve of the mother's elongated,
outstretched arm focuses the viewer's
attention on the little girl and the ten-
der, playful interaction between their
hands. The tilted angle of the vantage
point allowed the artist to silhouette
the figures against the backdrop of
the green lawn. Both wear white and
patterned dresses while the color of
their hair is contrasting—flax-blond
for the girl and dark brown for the
mother. This pastel once belonged
to James Stillman, who was one of
Cassatt's few close male friends. It
was given to The Metropolitan
Museum of Art by his son in 1922,
during the artist's lifetime.

her first one woman-show in her own country, at the New York branch of her Paris dealer. The exhibition proved to be less successful, however, and was a disappointment for Cassatt, who continued to consider herself an American artist despite the fact that she had been living longer in France than in her native country.

Her works were now regularly exhibited and published in art journals. About *Breakfast in Bed* a critic noted that although Cassatt was "by no means a great artist," one could find "on almost every one of her canvases, roughly, sometimes brutally composed, drawn, and painted, there is that touch, which by imparting to form and color some particular quality of effect, impossible to analyze, endows all her figures with the energy of life."

In 1894, the steady sales of her works enabled Cassatt to purchase the Château de Beaufresne at Mesnil-Théribus in the Oise valley, about 50 miles (80 kilometers) north of Paris. The château's garden with its pond served as a backdrop for several paintings and pastels such as *Summertime, Mother Playing with Her Child*, and *Nurse Reading to a Little Girl*. These outdoor settings added a greater degree of liveliness and naturalness to her compositions. Other works like *Maternal Kiss* and *Patty Cake* were more likely done in Paris, where Cassatt lived during the winter and spring. In 1898 she returned to the United States for the first time in over twenty-five years, visiting relatives, friends, and collectors. Only once more, in 1908, did she make this trip again, to see her

Maternal Kiss

1897, pastel on paper; 22 x 18 1/4 in. (55.8 x 46 cm). Bequest of Anne Hinchman, Philadelphia Museum of Art, Philadelphia. The lighter and more decorative approach found in narrative scenes of playing children was also applied to Cassatt's mother and child compositions of the 1890s. The mood is still tranquil and subdued, but the expressions are less distant and the gestures livelier. The detailed rendering of the girl's hair, ribbon, and dress serve to enhance a sense of informality and directness, while the voluminous waves of the mother's hair and blouse attest to the strength and self-determination of a modern woman.

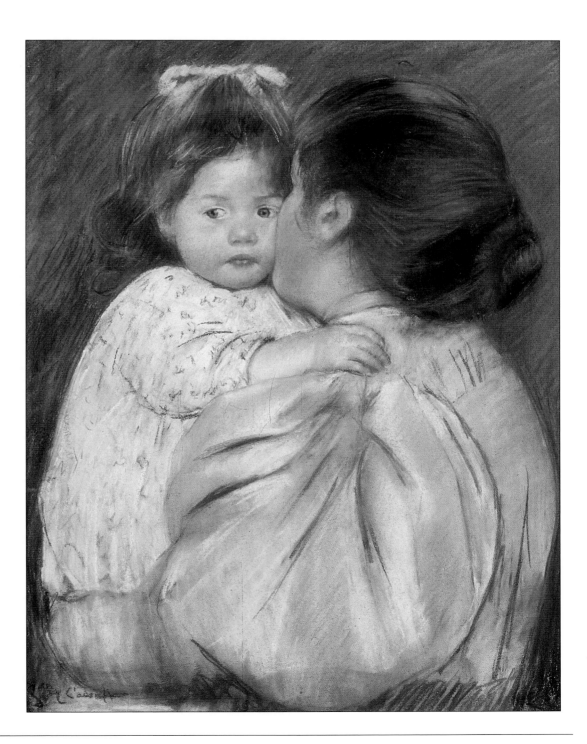

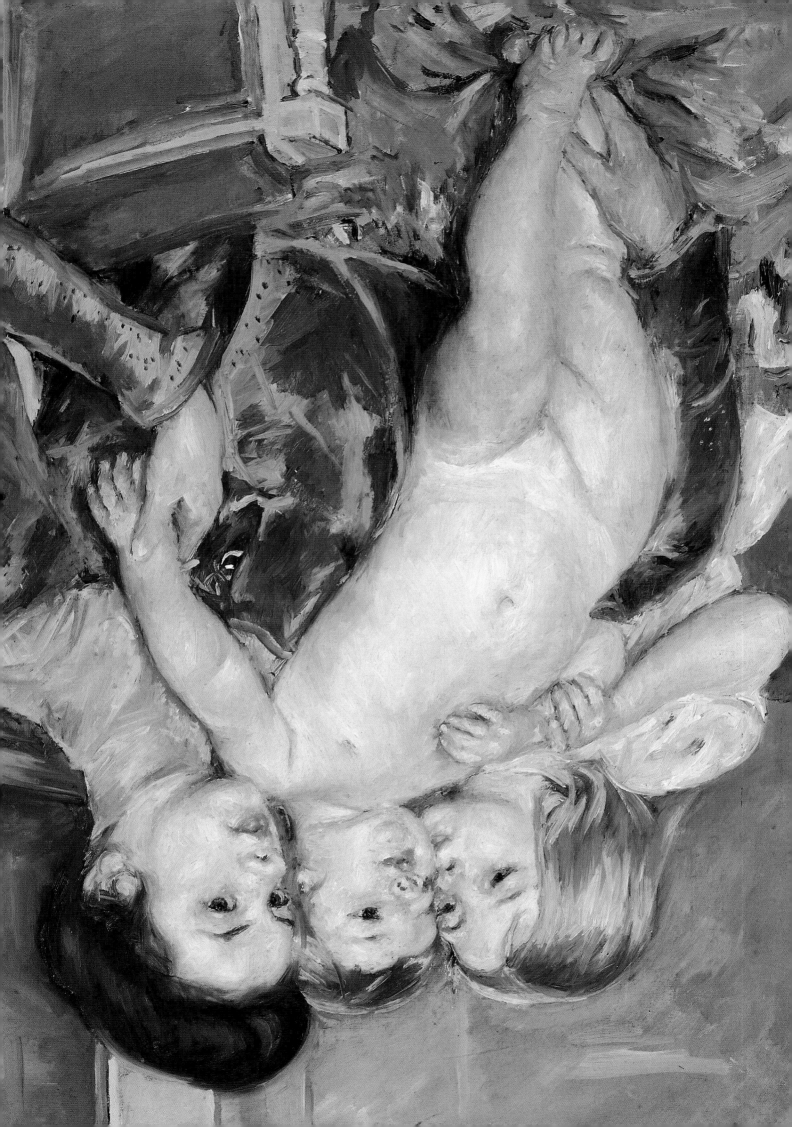

Mother Combing Her Child's Hair

c. 1901; pastel and gouache on tan paper; 25 1/4 x 31 3/5 in. (63.8 x 80.2 cm). New York, The Brooklyn Museum, Bequest of Mary T. Cockcroft. An enlarged, more elaborate setting is characteristic of Cassatt's later works. The figures are placed further back, thus allowing for a more complete view and a wider range of their activities. As in some Old Master paintings (which the artist was again studying at this time), the mirror effect is used not only to include the reflections of the two sitters, but also to depict other invisible parts of the room: a door and a curtained window.

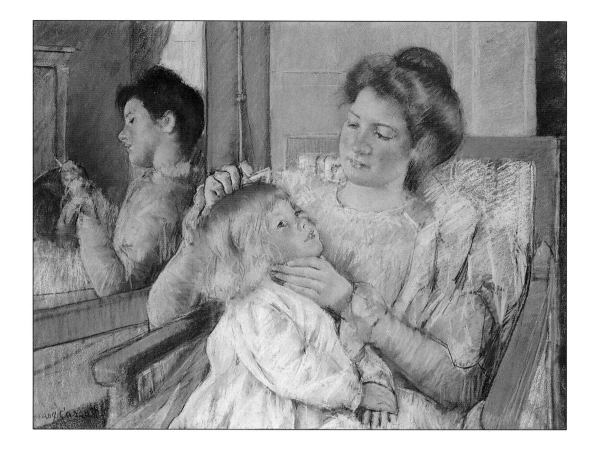

friend Louisine Havemeyer at the anniversary of the death of her husband Harry.

Fame and Recognition

In the meantime, Cassatt's increasing fame and recognition went hand in hand with a change in public taste, which by now had accepted the Impressionist and Post-Impressionist artists. A creative year and a half between 1901 and 1902 resulted in a group of new works, most-

The Caress

1902, oil on canvas; 32 7/8 x 27 3/8 in. (83.4 x 69.4 cm). Gift of William T. Evans, National Museum of American Art, The Smithsonian Institution, Washington, D.C.
Many of Cassatt's mother and child groups are modeled after Italian Renaissance paintings of the Madonna and Christ Child. In 1871, during her eight-month stay in Parma, Italy, Cassatt had the opportunity to study the works of Correggio and Parmigianino closely. The bold Mannerist curve of the baby's body dominates the composition, which is framed by the protecting arms of the mother. Her striking emerald blouse and lavender skirt are proof of the painter's skills as a colorist. The blond girl about to caress the baby's face was a model named Sara who appears frequently in Cassatt's later paintings.

ly mother and child scenes, which were a direct response to a trip she had made with her friends, the Havemeyers, to Italy and Spain. Once more, the influence of Old Masters can be felt in works like *The Caress*, where the sinuous lines of almost baroque exuberance create a richness and sensuousness rarely seen before. Again, the composition appears to be based on a traditional painting of a Madonna and child, with Saint John the Baptist as infant, although it is not possible to identify any specific source. *The Caress* was shown at the Seventy-Third Annual Exhibition of the Pennsylvania Academy of the Fine Arts in early 1904, where it received an award. Cassatt, however, critical of any jury system since her first experience with the Paris Salon, declined this honor, as well as others in later years. For her, art could not simply be judged by systematic criteria: "In art what we want is the certainty that the one spark of original genius shall not be extinguished, that is better than average excellence, that is what will survive, what it is essential to foster."

Similarly, she was an outspoken supporter of young, struggling artists and a strong defender of artistic freedom. The only concession she made to the public establishment was to become a Chevalier of the Legion of Honor in 1904, and this only because she was honored for her lifetime achievement in the arts and not for a spe-

cific work. This idiosyncratic behavior made her a hero among the younger generation of American artists in Paris after 1900, a position which she held even during the last years of her life, when she occasionally entertained newcomers with her reminiscences.

Cassatt failed, perhaps understandably, to comprehend the goals and achievements of a younger generation of artists that included Pablo Picasso and Henri Matisse, who were coming to the forefront with paintings which replaced realistic depictions with emotional interpretation through bold, bright colors. After visiting an exhibition of Matisse's Fauvist paintings around 1908, she exclaimed in outrage: "I have never in my life seen so many dreadful paintings in one place." Her own works continued to be imbued with the sweetness and charm of a realism whose days were already numbered.

The Last Years

Cassatt's last years were largely spent in solitude at the Château de Beaufresne, accompanied only by her longtime housekeeper, Mathilde Valet, or in the south of France. After the death of her last sibling in 1911 and of Degas in 1917, Cassatt was left with just a few friends. She wrote to the painter, George Biddle, "His [Degas'] death is a deliverance, but I am sad. He was my oldest friend here and the last great artist of the nineteenth century. I see no one to replace him." Suffering from diabetes and cataracts on both eyes, which eventually reduced her to near blindness, she found temporary renewal of her strength in her relationship with the American banker James Stillmann, who courted the artist and bought several of her paintings.

By the outbreak of World War I Cassatt had to give up painting entirely, but she preserved her original enthusiasm and devotion to art until the end. Cassatt died at the Château de Beaufresne on June 14, 1926, and was buried in the family vault at nearby Mesnil-Théribus.

Young Girl Reading (Fillette en Robe Bleu)

c. 1908, pastel on oatmeal paper mounted on linen;
25 5/8 x 19 3/4 in. (65.0 x 50.0 cm). Gift of
Mr. and Mrs. Louis Brechemin, Seattle Art Museum, Seattle.

In her later years, Cassatt's figure drawing became less consistent due to an increasing lack of vision, which eventually prevented her from painting altogether. Nevertheless, this portrait of a young girl reading near a window still conveys a masterly touch, particularly in the reflections of light on the girl's face and on her dress. The curving lines of her figure are set against the rectangular shapes of the chair and the window in the background. The likeness of this model, named Françoise, can be found in other works from this period.

Sara in a Green Bonnet

c. 1901, oil on canvas; 16 5/8 x 13 5/8 in. (42.0 x 34.5 cm).
Gift of John Gellatly, National Museum of American Art,
The Smithsonian Institution, Washington, D.C.

In a number of child portraits from about 1900 onward Cassatt exploited the new fashion of the day by dressing her models in large costumes and elaborate hats as if they were adults. By selecting or at times even commissioning these dresses herself, Cassatt must have made a deliberate choice, although it is often a puzzling one. The children were engaged from the nearby village, yet these pictures are not portraits in the traditional sense since they were neither commissioned by the sitter's family nor meant to be given to them; instead they were intended for public exhibition and sale.

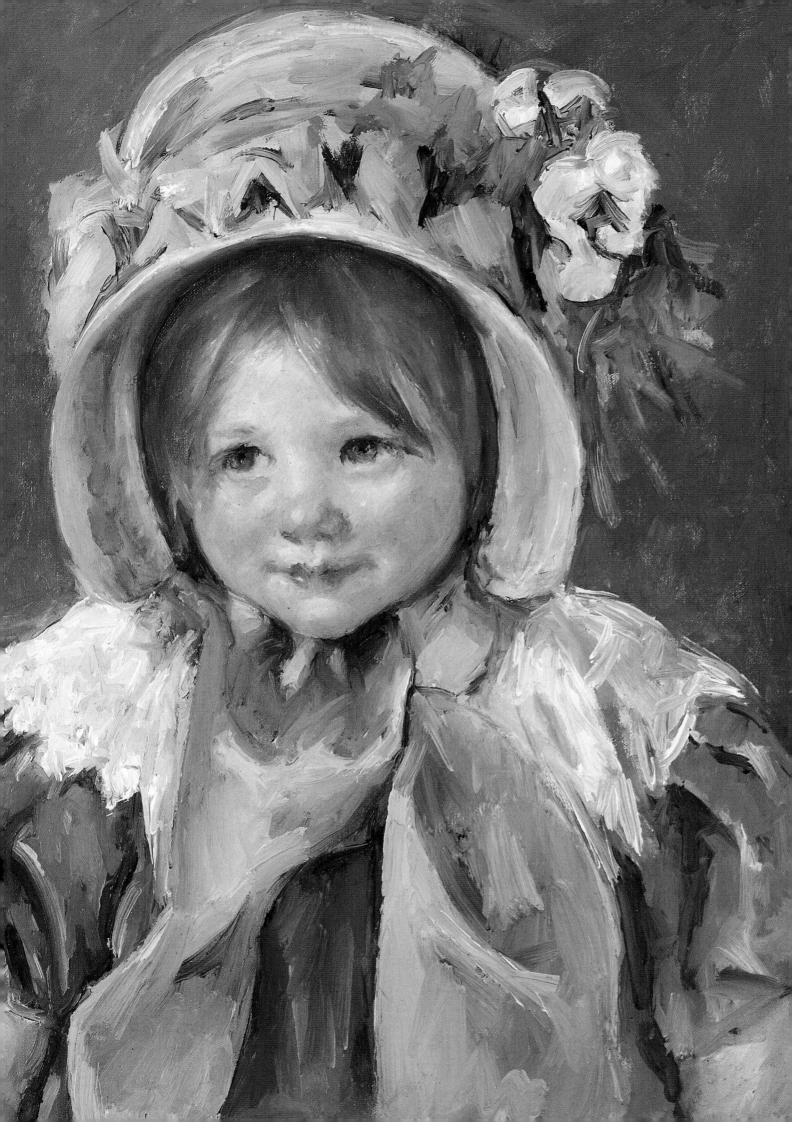

INDEX